A DAY'S RIDE *from* HERE

* VOLUME ONE *

A DAY'S RIDE *from* HERE

✳ VOLUME ONE ✳

MOUNTAIN HOME, TEXAS

Clifford R. Caldwell

THE
History
PRESS

Published by The History Press
Charleston, SC 29403
www.historypress.net

First published 2011

ISBN 978.1.5402.3075.1

Library of Congress Cataloging-in-Publication Data

Caldwell, Clifford R., 1948-
A day's ride from here / Clifford R. Caldwell.
v. cm.
Includes bibliographical references and index.
Contents: v. 1. Mountain Home, Texas -- v. 2. Noxville, Texas.
ISBN 978-1-60949-393-6 (v. 1) -- ISBN 978-1-60949-394-3 (v. 2)
1. Mountain Home Region (Tex.)--History. 2. Noxville Region (Tex.)--History. 3. Kerr
County (Tex.)--History, Local. 4. Kimble County (Tex.)--History, Local. 5. Kerr County
(Tex.)--Biography. 6. Kimble County (Tex.)--Biography. 7. Frontier and pioneer life--Texas-
-Kerr County. 8. Frontier and pioneer life--Texas--Kimble County. 9. Ranch life--Texas--
Kerr County. 10. Ranch life--Texas--Kimble County. I. Title.
F394.M82C35 2011
976.4'884--dc23
2011023478

TEXAS IS A ROUGH PLACE

*"Some say there ain't no God
South of the Red River
and there ain't no law West of the Pecos.
But wherever good people go
law and order will soon follow,
and once you get to Texas you discover
that God was here first."*

—Anonymous

CONTENTS

ACKNOWLEDGEMENTS

M uch of the credit for inspiring me to write this book goes to my dear friend, Joseph Luther of Kerrville, Texas. Joe skillfully lured me into participating in the Kerr County Historical Commission. His encouragement to expand my research work on local outlaws, lawmen and cowboys resulted in my discovery of a supply of material to immerse myself in for decades to come. Many other members of the historical commission contributed either material or support. Their kindness and generosity is greatly appreciated.

Another friend, Mark Dworkin of the Wild West History Association, deserves a special thank-you for his capable and professional assistance and for taking the time to offer some needed editorial comments. His encouragement helped me to bring this book to a successful conclusion. Mark is the classic example of the old adage "If you want something done, give it to a busy man." He gave freely of his time and knowledge, and for that I am grateful.

Last, but by no means least, I thank all of the lawmen, outlaws, ranchers, settlers, cattlemen and cowboys whose eventful lives and heroic deeds made writing this collection of stories possible.

INTRODUCTION

If a man's from Texas, he'll tell you. If he's not, why embarrass him by asking?
—John Gunther

From about the age of thirteen, I have been obsessed with history. My initial interest was in the Civil War. After concluding that it was not the war I was really interested in, but rather the postwar Reconstruction era, I changed my focus. For years I dragged my young family, often kicking and screaming, through one old fort or museum after the next until I finally succeeded in understanding that my true passion was the American West. The downside of my passion for the West is that I may have inadvertently caused irreparable damage to my children's interest in all forms of history as a consequence. They carry the evidence of this childhood scarification to this day and run when they hear me begin to talk about some old lawman's grave I found last week or another incident I heard about involving outlaws. But alas, there is still hope! I have a grandson, and I plan to fill his mind with all forms of outlaw and lawman trivia.

Several years ago, I became extremely interested in the life and times of the famous Texas cattle king John Simpson Chisum. That pursuit led me to immerse myself in the history of the Lincoln County War in New Mexico and the life of Billy the Kid. My John Chisum studies proved to be extremely satisfying and educational, filling a huge gap for me in the lore of the western cattle trails and cattle barons of the era. Regrettably, my work on the Lincoln County War, although fascinating, thrust me into one of

the most contentious areas of study of the American West imaginable. Did Butch Cassidy survive and live a long, productive life in South America? Was Custer incompetent? Was Wild Bill a hero? The list of topics that are debated endlessly, as well as the log of conspiracy theories concerning the Old West, is practically endless.

One day, I was sitting in my office at home and gazing out the window across at the meadow filled with live oaks and framed by the skyline of the Texas Hill Country. It occurred to me that, like the classic story of the man not able to see the forest for the trees, I was surrounded by a wealth of history sitting right under my nose. Yes, that was it! No more endless verbal battles over the obscure details of Billy the Kid's death or the configuration of his Colt revolver. No more hours spent on quarrelsome topics or the latest conspiracy theory involving another "newly discovered" Billy the Kid photograph.

As I sat and pondered the marvel of it all, I realized that just outside my door, not more than a day's ride on horseback from this very spot, some of the most interesting events in Texas history took place. A researcher can find a lifetime supply of material for stories about the cowboys, Indians, lawmen and outlaws who roamed these hills more than a century ago. Like C.L. Sonnichsen, the quintessential "grass-roots historian" who went door to door through the back country of Texas searching for information from often reluctant sources and digging up long-forgotten records from musty court house cellars, I could also chronicle the lives of these long-forgotten characters. At that point, I began to focus my interest in the history of the American West on things that took place "a day's ride from here."

We are blessed to live in the tiny community of Mountain Home, Texas, located in Kerr County about sixteen miles west of the county seat in Kerrville. Traveling northwest from San Antonio, the relatively flat country of the Rio Grande Valley gives way to rolling hills as one climbs quickly in elevation. Kerr County lies roughly fifty miles northwest of San Antonio, on the Edwards Plateau, which traverses south-central Texas. The county is named for James Kerr, an "Old Three Hundred" colonist and an important figure in the Texas Revolution. The area around the county seat of Kerrville has been the site of human habitation for thousands of years. Archaeological artifacts found along the Guadalupe River and its numerous forks and feeder creeks indicate that humans arrived here about six to ten thousand years ago. Various tribes—including the Lipans, Apaches, Comanches and Kiowas—made this place their home or passed through as they hunted the region.

The first attempt at Anglo settlement in the area of Kerr County was in 1846, when Joshua D. Brown led a group of ten men to the Guadalupe

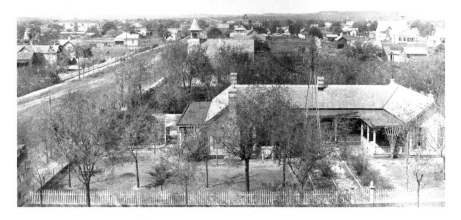

View of Kerrville from Tivy House. *Courtesy of Kerr County Historical Commission Archives.*

River and established a shingle-making camp at the site of present Kerrville. After only a short time, Indians drove them off. Undaunted, they returned to the site, which they had originally named Brownsburough in 1848. By 1860, Kerr County had a population of 634. Kerr County's population grew rapidly, reaching practically 4,000 by 1882.

Indian depredations in the county would continue until almost 1880, adding mightily to the constant struggle of life on this yet unsettled frontier. Bands of Indians traveled north from the relatively safe haven of Old Mexico, crossing the Rio Grande near the confluence of the Devils River near present-day Comstock. From there they continued up through the fertile canyons that lie beyond Uvalde, looting ranches and killing settlers along the way. The raids ordinarily centered on the Kerr and Gillespie Counties area, where their efforts were customarily rewarded with a rich harvest of horses and cattle, which they promptly took with them back to Mexico.

After the Civil War, the rapid growth of the outlaw population added to the plight of the local citizenry. Returning from the war, many Confederate veterans found their families and fortunes in ruin, the lands in waste and the prospect of employment slim. The government—now run largely by

former Union officers and loyalists and carpetbaggers from the North—was exacting its revenge on Texas. A disproportionate number of them turned to a lawless life. During the decade following the Civil War, Kerr County suffered under the burden of continued Indian raids and outlaw activity. In the mid- to late 1870s, the cattle trails north brought thousands of head of livestock through the county, traveling up the Western Trail from the Rio Grande Valley. Along with the cattle came an army of cowboys. Interspersed in the ranks was an odd collection of drifters and ne'er-do-wells. This further added to the mix of local excitement.

The State of Texas soon conceived a solution to the continuing Indian depredations and the influx of outlaws, creating the Frontier Battalion of Texas Rangers. Formed on 10 April 1874 under Major John B. Jones, the battalion was composed of six companies, with about seventy-five rangers per company. Company F, chosen to protect the area around Kerr County, was under the command of Captain Neal Coldwell, with Pat Dolan serving as first lieutenant and F.W. Nelson as second lieutenant. The rangers were stationed on the Guadalupe River, where they mounted frequent patrols covering every corner of the sector. After locating their original camp at the headwaters of Johnson Creek on the John Joy Ranch following the massacre

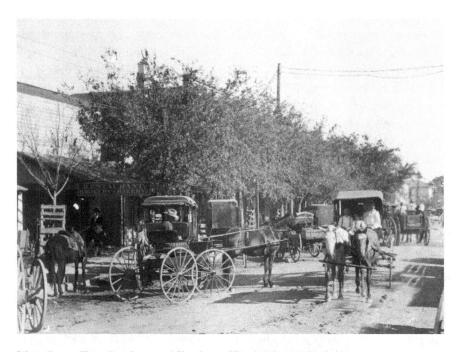

Water Street, Kerrville. *Courtesy of Kerr County Historical Commission Archives.*

of the Dowdy family in October 1878, Lieutenant Nelson Orcelus Reynolds soon moved the encampment to Contrary Creek several miles farther west. Major Jones had earlier explored the area and suggested the camp be located near the headwaters, but after reexamining that rugged area, Reynolds believed that the best site would be near the mouth, where Contrary Creek flows into Johnson Creek. From their camp on Contrary Creek, Coldwell's men "thinned out" more than three thousand Texas outlaws.

In 1881, the last Indian raid in southwest Texas took place when Lipans struck the McLauren home at Buzzard's Roost in the Frio Canyon. John McLauren, who was away at the time, avoided death, but his wife, Kate McLauren, and teenager Allen Lease, a neighbor who was living with the family, were both killed in the raid.

Some have reported that more than 300,000 head of cattle were driven from the Kerr County area to railheads in Kansas during the heyday of the Western Trail. Herds of cattle ranging in size up to about 2,500 head were assembled on Town Creek, north of Kerrville, and driven up the Western Trail to the Red River, Oklahoma, Kansas and beyond. With the passing of the usefulness of the trail by the late 1880s, much of the rowdy behavior disappeared with the departure of the transient cowboys.

At 11:45 a.m. on 6 October 1887 a new chapter in Kerrville history was penned with the arrival of the first San Antonio and Aransas Pass Railway train. Rail service marked the start of a new hopeful era for Kerr County. On board the six Pullmans drawn by the steam locomotive A.C. Schryver

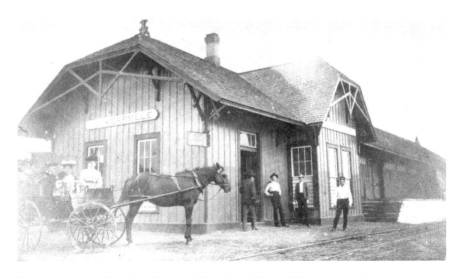

First train station, Kerrville. *Courtesy of Kerr County Historical Commission Archives.*

were 502 passengers: 200 from San Antonio, 131 from Boerne, 141 from Comfort and 30 from Center Point. That was 200 more people than lived in Kerrville at the time. The arrival of the train was celebrated with great fanfare, including the rousing music of the Fredericksburg Mexican Brass Band. A procession was formed and led by Charles Schreiner. The festive group marched off to the barbecue grounds, where fourteen cows, twenty sheep and a number of small goats had been prepared for the feast. Regrettably, hopes for a thriving new era for Kerr County would soon fade as the railroad business dwindled.

By the 1920s, Kerr County, based largely on its favorable climate, had developed a reputation as one of the healthiest locations in the country. Those seeking relief from tuberculosis, more commonly known as consumption at the time, and other ailments beat a path to the region. Numerous churches and organizations built summer camps in the countryside and along the Guadalupe River and other prominent waterways in the region. Civilization had reached Kerr County.

Most residents of Kerr County today have little more than a clue about the richness, not to mention the roughness, of its past. Conveniently located historical markers provide the newcomer, or the tourist, with a "drive-by" snapshot of history. Few would know that while enjoying a delightful lunch in a downtown bistro they are seated on the spot where many a drunken

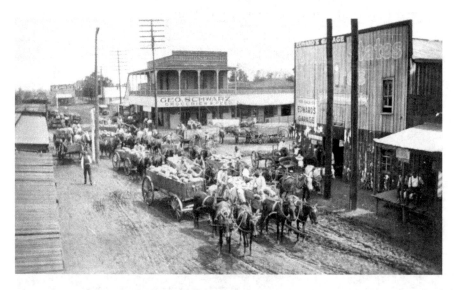

Downtown Kerrville, Geo. Schwarz Grocery & Feed. *Courtesy of Kerr County Historical Commission Archives.*

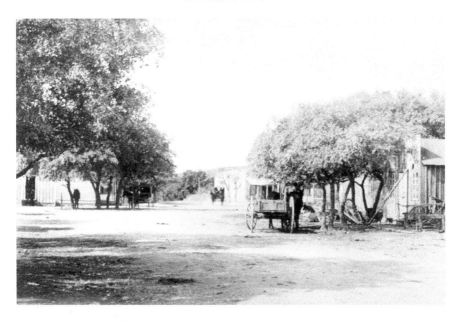

Town of Ingram. *Courtesy of Kerr County Historical Commission Archives.*

brawl or shootout took place—or that upstairs one of the prominent local sporting houses flourished. The sights and sounds of the late 1800s were markedly different at the corner of Mountain Street and Water Street.

Some historians would prefer to ignore the less attractive elements of the county's past, but the whole is always composed of the sum of its parts, and to ignore the "gritty" parts would be analogous to rewriting history. Crossing the Francisco Lemos Bridge is not a noteworthy event today, but in the 1880s thousands of head of cattle followed that path north to Kansas. In those days, if you were looking northwest from where the present-day HEB grocery store parking lot is, you could see, and no doubt smell, the milling herds as they restlessly awaited the journey. Strolling through Walmart today, one would scarcely consider that it was once the site of an army artillery range or that just down the road toward Ingram a few miles, one of the most famous hangings in Kerr County's history took place.

The various tales contained in the following chapters are about people from here or those who left their mark while passing through here. They are about events that took place here—or at least within a day's ride from here.

INDIAN DEPREDATIONS AND THE BATTLE OF BANDERA PASS

Texas has yet to learn submission to any oppression,
come from what source it may.

—Sam Houston

Following the Great Raid of 1840, in which the Comanches under Buffalo Hump sacked Victoria and Linnville, Texas president Sam Houston felt that he had to strengthen frontier defenses to prevent similar pillages from taking place in the future. Houston appointed several companies of Texas Rangers, known as Ranging Companies, with one particular company under the command of Captain John Coffee Hays.

John Coffee Hays was born on 28 January 1817 at Little Cedar Lick in Wilson County, Tennessee. He grew up with a fondness for horseback riding and shooting. Captain Hays was fifteen when tragedy struck: his parents died of yellow fever. Jack and two other siblings were sent to the plantation of Harmon Hays, a family member, in Wilson County, Tennessee. Plantation life didn't suit Jack's adventurous spirit well, so he struck out on his own to become a surveyor in Mississippi. After two years, he had saved enough money to enroll at the Davidson Academy in Nashville. Hearing of the Battle at the Alamo, Hays set off to join the cause of Texas independence. At the advice and urging of Sam Houston, Hays enlisted in the Texas Rangers, joining the company led by scout Erastus "Deaf" Smith that was responsible for covering the expanse of territory from San Antonio to the Rio Grande. The company was under the command of Colonel Henry W. Karnes. In this

Bandera Pass. *Courtesy of Kerr County Historical Commission Archives.*

Texas Ranger captain John Coffee "Jack" Hays. *Courtesy of Dr. James Hays, Early, Texas.*

role Hays took part in an engagement with Mexican cavalry near Laredo, assisted in the capture of Juan Sánchez and rose to the rank of sergeant. He settled in San Antonio, and after appointment as deputy surveyor of the Bexar District, Hays combined soldiering and surveying for several years. The more he learned about Indian methods of warfare, the better he protected surveying parties against Indian attacks.

Legend has it that on one particular scouting expedition—said to have taken place in 1841, although the exact date of this battle has long since been lost to history—Captain Hays intended to travel to a location near the head of the Guadalupe River. From there he had planned to scout some of the canyons in the mountainous area and return to camp. The scouting party consisted of thirty to forty rangers, although some report it to have been as high as fifty. Included in this group of rangers were several celebrated Indian fighters, including Ben Highsmith, Creed Taylor, Sam Walker, Robert Addison "Ad" Gillespie, P.H. Bell, Kit Ackland, Sam Luckey, James Dunn, Tom Galberth, George Neill and Frank Chevallier. Some of Captain Hays's regular group of rangers were still in prison in Mexico after being captured during the ill-fated Battle of Mier.[1] Among those who remained in the Mexican jail was the legendary William Alexander Anderson "Bigfoot" Wallace, claimed by some historians to have been a participant of the Bandera Pass fight.

Captain Hays's group headed northwest, crossing the Medina River near the present-day town of Castroville and continuing to a location near what is now the town of Bandera. Here the group made camp for the night. In the morning, all headed north toward Bandera Pass, arriving at about 10:00 a.m. Comanches observed the group's movements and laid a trap for it at the pass. The Indians had all the advantage from the outset, catching the rangers in the narrow, 125-foot-wide pass with its steep, rock-faced hills on both sides, filled with narrow canyons and rock features that provided excellent concealment. The Indians allowed about one-third of the scouting party to pass before opening fire. The initial barrage threw the men and horses into turmoil and confusion as the greatly outnumbered rangers tried to find cover. The battle raged for some time. The Indians were armed with guns, as well as bows and arrows and lances. Both sides suffered numerous casualties. The perspicacious Captain Hays, cool and collected as always, ordered his men to be "steady there boys…dismount and tie those horses, we can whip them…No doubt about that."

The combat was often at close range, with pistols, knives and bare hands. Before the fight was over, nearly one-third of the rangers were killed or wounded. The Indians retreated north, while the rangers headed to

the southern end of the pass, making camp near a spring to nurse their wounded and bury the dead. In total there were five rangers killed and six wounded. Accounts of the day are somewhat imprecise, but it is claimed that Ranger Jackson was killed, and the list of wounded included Sam Luckey, Kit Ackland, James Dunn, Ben Highsmith and Tom Galbreath.

Most accounts of the Bandera Pass incident have been extracted from the version given by author and historian Andrew J. Sowell in his historic work *Texas Indian Fighters*. Regrettably, the sheer paucity of information about the Bandera Pass fight has, for years, been problematic. The majority of contemporary historians and authors have, relying entirely on the accuracy of Sowell's earlier work, dated this battle as having occurred somewhere between 1841 and 1843. Recently, several noted Texas historians have raised strong questions concerning the location of this now infamous confrontation. The evidence they offer is compelling.

Three rangers who participated in the fight (Benjamin F. Highsmith, Thomas Galbreath and Creed Taylor) gave oral histories about the battle. We can say with some certainty that the encounter branded as the "Battle of Bandera Pass" did not take place in 1841 or 1843, which are the two years most frequently cited and the dates that appear on virtually all of the monuments and plaques. A quick examination of the ranger muster rolls for 1841—and for 1843–45—shows that neither Galbreath nor Highsmith were a part of Jack Hays's company. But both Highsmith and Galbreath claim to have fought with Hays during the battle that has been identified at Bandera Pass. Creed Taylor served with Hays in 1842. Although Highsmith claimed 1843 as the year of the encounter, Taylor cited June 1841 (he also claimed 1840 as the correct year during a separate interview). In all likelihood, Taylor meant to say June 1842, since we know that he was with Jack Hays that year.

Creed Taylor claimed that between twenty-five and forty rangers were involved in the scrap. Jim Nichols, a veteran of the 1840 Plum Creek fight, stated that the rangers faced off against as many as two hundred Comanche Indians in the encounter. But according to respected historian and author Stephen L. Moore, Sowell seems to have intermixed details from the Taylor, Galbreath and Highsmith stories with the 1844 Walker's Creek fight.[2] Unfortunately, there is no "Walker's Creek" on any Texas map, period or otherwise. The author, as well as other historians, believe that Walker's Creek may have been the earlier name for the small stream now called Sister Creek, near Sisterdale, Texas. As for the location of this epic battle, the only source that placed the location as Bandera Pass was Sowell. There are no primary sources to support his claim. The written accounts of both Creed

Taylor and Jim Nichols, whose story seems to be the most reliable, positions the fight in Kendall County, along the banks of the Guadalupe—perhaps at the Pinta Trail crossing near present-day Waring. The correct number of combatants on both sides is also widely disputed and may have been as few as about a dozen Texas Rangers and sixty or so Comanche Indians. Thus, the convoluted legend of the Battle of Bandera Pass continues, with new twists and turns being uncovered every year. The fight probably took place in Kendall County, as Moore claims. Contrary to many reports, there were no Texas Ranger casualties during this encounter. James Dunn, a San Antonio man who was captured by the Comanches during the battle and later escaped, reported to Jack Hays that the Indians had suffered twenty-three casualties and that among the thirty-six additional warriors who were wounded, thirteen died shortly after the engagement.

Dare I even mention the part of the myth involving the famous Colt Paterson revolver? Once again, folklore seems to have gotten in the way of fact. Some have reported that the newly invented Colt revolving pistol called the Paterson model was used at the Bandera Pass fight. Given the fact that many early records were destroyed, the best accounts available came from individuals who were there at the time and gave oral testimony many years later. Those men claim that the actual place where they first used the new Paterson Colt was during a later encounter in June 1844, when Captain Hays took about fourteen men on a scouting party up the Nueces Canyon.

Jack Hays's rangers were first equipped with the new, five-shot revolving pistol manufactured by Colonel Sam Colt in 1844. On 1 June 1844, Hays and fifteen rangers left camp armed with the new Colt and rode north between the Llano and Pedernales Rivers. They later wheeled toward San Antonio and camped near Walker's Creek, four miles east of the Pinto Trace on 8 June. Shortly thereafter, they encountered a force of about sixty hostile Indians, including Comanches, Kiowas and Shoshones. The Paterson Colt first drew blood on the Texas frontier during this battle.

The Indians had been accustomed to charging a ranger position after they had heard the sound of one shot having been fired. They knew that after the shot they had several seconds to reach a ranger's position before he would have time to reload and fire again. It is said that with the new Colt revolver many Indians were caught in the open while making a headlong charge trying to reach the rangers, not aware that the rangers had five shots to fire before having to reload the Colt.

Captain Hays ordered his men to "stand your ground, hit something when you shoot and then run among the Indians and give them no chance

to retreat." This they did, inflicting tremendous casualties. According to a later report by a friendly Delaware Indian named Bob, they lost half of their warriors in the fight. The wounded continued to die along the hundred-mile trek back to the Devils River crossing into Old Mexico. I hope that at some future date a newly discovered relic of this fight will aid us in continuing to learn its secrets.

These two major Indian fights involving Captain Hays and his Texas Ranger Ranging Company during the 1840s were by no means the only, or the last, incidents of Indian depredations in Kerr County. Although the precise date on which the Indian raid at the home of Matthew and Rachel Wayland of northern Kerr County took place has been lost to history, it is believed to have taken place during the spring of 1870. Under siege by Indians, Matthew and Rachel Wayland barricaded themselves in their cabin. Afraid to leave and surrender to a band of marauding Indians what they had worked so hard to carve out of this hostile land, these brave farmers held out through the night. When dawn finally broke the following day, an old-timer named Burk Kennemer who was passing by the area saw what was happening and came to their aid. On Kennemer's advice, the Waylands reluctantly left their home and headed toward Fredericksburg to safety. Shortly after leaving their cabin, they found their escape path blocked by the Indians. The Waylands returned home, bringing their horses inside to protect them. Burk Kennemer, now alone, bravely rode on in a desperate search for help. As the Indians pounded on the door, Matthew considered letting the horses out, thereby giving over the main prize their captors desired. Rachel Wayland, displaying the true grit of a frontier Texas woman, refused to let her husband give up the horses. Eventually, a group of German settlers from Fredericksburg arrived and rescued the Waylands.

On 17 November 1870, the mail rider from Austin to Sisterdale noted that a party of Indians had chased him on the ninth, the same day Indians took captive a thirteen-year-old black boy from the town of Comfort.

On 13 May 1873, Indians raided into Kerr County and stole a great deal of livestock. Kendall County had also been recently visited by the Indians, suffering heavily in stock losses according to the *Galveston Daily News* report of this date.

In the nearby village of Medina, which lies just over the Kerr County line to the south, Mr. Joseph Moore and his daughter, Elizabeth, were killed by Indians on 4 July 1872. One year later, Mrs. Moore was killed near the Jones home in Medina. They are buried at the Arnold Cemetery on the Hick's Ranch, Medina, Bandera County, Texas.

By 1874, the *Galveston Daily News* reported that the number of white men and women killed by raiding Indians each year in Texas was at least one hundred. That estimate was accompanied by the report that the number of cattle and horses taken by marauding Indians across Texas was over 100,000.

On 14 November 1874, another band of about sixteen Indians was reported to have been raiding in the area of Kerr County, gathering up all of the horses they could find. Roughly forty head were taken from the Spring Creek settlement. The party of Indians had last been seen at the head of Johnson Creek. The 18 November 1874 edition of the *Galveston Daily News* reported that nothing further had been learned as to the whereabouts of this group of raiders.

Not long after this visitation, there are reports of an Indian raid in Kerr County on 20 February 1875. During that raid, Indians made another visit to Kerr County, several head of cattle were killed and six head of horses were stolen. The raiders managed to get away without a fight.

On 10 May 1876, Ranger captain Neal Coldwell, commander of Company F of the Frontier Battalion, reported that two bands of Indians

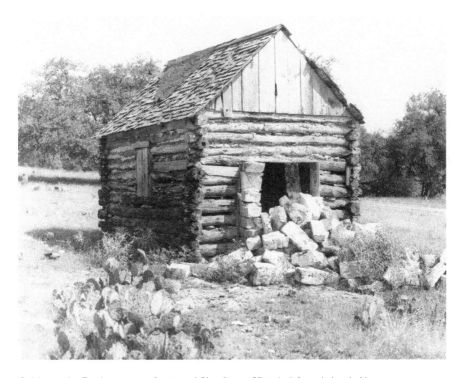

Cabin on the Real property. *Courtesy of Kerr County Historical Commission Archives.*

had been seen in Kerr County. Each group numbered about ten. A man and a boy were killed by one group on the Nueces, and another man wounded on the Llano. Captain Coldwell estimated that the Indians drove off about thirty head of horses. Rangers were unable to overtake the group, and it managed to escape. The trail of another party consisting of about thirty individuals was discovered.

The Terry family, along with Jack Hardy, a freed slave who had earlier belonged to Dr. John Ridley, lived near Center Point along the Guadalupe, about half a mile above the town.[3] Indians took Hardy captive in the fall of 1876. Shortly after his capture, the same group of Indians brutally murdered the Terry family. The Terrys lived about a mile and a half south of Center Point.[4] The Indians surprised Mr. Terry and four of his children, who were some distance from the house. They killed him and two of the children, severely wounding another and taking the nine-year-old daughter off with them. When the Indians attacked Mr. Terry, who had been sitting on the ground riving cypress blocks, he sprang to his feet and ran about forty yards before he was shot and lanced. Mrs. Terry escaped, leaping over the yard fence and tossing their young baby, Joe, who was in her arms at the time, into the high weeds. This swift move on her part saved the baby from discovery, capture or, perhaps, death. The Indian party then headed south over the Bandera Pass, proceeding over the mountains and through Hondo, Seco and Sabinal Canyon to below Utopia. Jack Hardy managed to escape in December 1876 and was rescued by a man named John Dickson from Frio. The severely injured Hardy said that Dickson "treated him kindly, giving him food and clothing and nursing him back to health."

A group of men from the area under the command of John Paterson was dispatched to pursue the band of natives and caught up with them in the Dry Frio Canyon, where a serious battle took place. They rescued the little Terry girl and continued south after the Indians, presuming that they would cross into Mexico at their normal jumping-off point at the mouth of the Devils River. This time, the Indians made their ford some distance away, at La Villa Nueva. Due to the swollen conditions of the river, they managed to escape back into Old Mexico as the posse abandoned the pursuit.

The *Galveston Daily News* reported that on Wednesday night 27 December 1876, a band of thirty Indians passed within seven miles of the town of Kerrville, stealing horses from James Lyle, Howard Henderson and Mr. Callaghan. It was also reported that Mr. Sam Spears of Kerr County was killed by the band on Tuesday or Wednesday night. A detachment of Lieutenant Moore's Rangers, accompanied by a large number of citizens,

was reported to have been in close pursuit. There are no records indicating if this group was successful or not in its quest.

In the winter of 1876, another Indian raid took place at the family home of William and Nancy Alexander, who lived in Kerr County, about eighteen miles above the town near present-day Hunt, Texas. The Alexanders' daughter, as well as son-in-law Mr. Wachter, were living with the couple at the time. At the time the raid took place, Mr. Wachter and Mr. Alexander had gone to Fredericksburg with shingles, leaving the two women alone. When the Indians struck the place, Mrs. Nancy Wachter, who is said to have been a "stout woman," saw an Indian in the doorway and fearlessly struck him with an iron. She then ran out the door, pushing her way through a group of Indians who were firing arrows at her. She fell over a log, lying there for a moment before crawling off into a thicket. The Indians presumed that she had been killed and turned their attentions to the mother, Mrs. Alexander. Mrs. Wachter headed downriver to where her brother, Wren Alexander, and a boy were making shingles. By the time Wren returned, the Indians had burned the home to the ground. Sadly, the remains of Mrs. Alexander were discovered among the ashes.

On 30 June 1877, Indians once again raided Kerr County, getting away with about thirty horses. This group was suspected of being the same band that was reported several days earlier depredating along the Nueces. Texas Rangers and United States troops pursued them, but to no avail.

On 15 August 1877, Captain Neal Coldwell's Company A reported that during the preceding month his company had logged an impressive 1,632 miles on scout and made twenty-two arrests. This equaled the earlier ranger record set by Major Jones during his raid in Kimble County. Among the outlaws apprehended by Coldwell was John Bennett. Bennett was charged with the murder of two black men in Travis County. He was also charged with the murder of a man named Champion—who, it seems, had "stood down" a Burnett County deputy sheriff with a double-barreled shotgun. The passing of Mr. Champion was probably not mourned in Burnett County.

All of the foregoing Indian depredations left scars on the community, but none so enduring in the memories of old-timers and descendants of early pioneers as the massacre of the Dowdy family of Mountain Home in 1878.

Sadly, the raids were not over. In June 1880, the *Galveston Daily News* reported that depredations along the Brazos continued. Perhaps the last raid in this part of Texas took place in the Frio Canyon on 19 April 1882, when the McLauren family was attacked. Kate McLauren was killed, along with a young man named Allen Lease who lived with them at the time. This tragedy ended more than thirty years of seemingly continual Indian depredations in the region.[5]

THE MASSACRE OF THE DOWDY FAMILY

In the night of death, hope sees a star,
and listening love can hear the rustle of a wing.
—Robert Ingersoll

One mournful event from the annals of Kerr County history that has not been entirely forgotten, at least by a handful of local citizens, is the tragic slaying of the Dowdy children. Surviving descendants of the Dowdy clan still reside in the county and have helped to keep the memory of their ancestors alive. The bloody massacre of the Dowdy children occurred in 1878, just west of the town of Ingram, near Mountain Home.

The present-day community of Mountain Home, first called Eura, was settled about 1856 by storekeeper Thomas A. Dowdy as a supply center for area ranches. Soon after, the tiny community received its first post office and named H. Louis Nelson postmaster in 1879. The pioneer family of James Dowdy (1818–1900) and wife Susan (1830–1913) moved from Goliad to Kerr County in 1878 and settled on Johnson Creek, not far from the headwaters of the Guadalupe River. By 1878, the couple had five children: Thomas A., born 21 August 1854; Alice C., born 1 January 1860; Martha F., born 31 March 1862; Susan V., born 12 September 1864; and James C., born 15 December 1867.

The Dowdys had recently arrived at Mountain Home and had not yet unpacked all of their belongings when they suffered a horrendous tragedy. Raiding Indians killed four of their children—Alice, Martha, Susan and James—while they were tending sheep near their home.

The attack took place in the fall of 1878 near the Dowdy homestead, located about three and a half miles northwest of the present-day town of Ingram, along Johnson Creek near Highway 27. According to a report by Texas Ranger captain James B. Gillett that he filed on 5 October 1878, Mr. Dowdy, who owned two to three thousand head of sheep, had been grazing the flock several miles from his home. He had recently contracted for delivery of his winter supply of corn; thus when the first load of grain arrived he sent his three daughters out to where the sheep were pastured to relieve his eldest son so that he could assist his father with the unloading while the girls stayed with the youngest son to tend the sheep.

When the eldest son, Thomas, and his mother Susan returned to the flock about an hour later, they discovered the younger brother and all three of the girls murdered, presumably by a roving band of Indians. Tragically, Susan Dowdy was the one who first came upon the bodies of two of the girls and the boy. Guns as well as bows and arrows were used in the attack. Ample evidence of both was found at the site. The pantaloons of the boy were taken, along with the outer garments of the three girls. The *Galveston Daily News* account of 10 October 1878 claimed that "there was no evidence of the girls have been outraged, nor had their scalps been taken." From observing the sign on the bluff just above the spot where the sheep had been grazing, Dowdy surmised that the Indians had been watching his stock, and when they saw the only adult male leave, they descended upon the defenseless children and killed them.

Some have reported that Mrs. Dowdy would not allow the spear points and arrowheads to be removed from the children, fearing that somehow it would cause them further pain.

The nearest ranger camp was one hundred miles distant. A posse of local citizens was formed and pursued the band of Indians for nearly two hundred miles, eventually losing their trail near the Devils River. Immediately after the incident, Kerr County called on General Jones for the assistance of the Texas Rangers. In short order, Lieutenant N.O. Reynolds arrived with a troop of rangers and made camp near the Dowdy Ranch. They remained there for the winter. Captain James B. Gillett, who was with that group of rangers, later recalled that "at the time of the murder the ground was soft and muddy from a recent rain, so one could see for months afterward where the poor girls had run on foot while the Indians charged on horseback." He continued: "I remember one of the girls ran nearly four hundred yards before she was overtaken and shot full of arrows by a heartless redskin." Gillett and others had reckoned that the Indians who committed this reprehensible

act had been Lipans or Kickapoos. Both tribes lived in the Santa Rosa Mountains of Old Mexico and frequently raided into south Texas.

A report in the 27 November 1878 edition of that *Galveston Daily News* seems to contend that after further investigation, administrators at Texas Ranger Headquarters believed that perhaps the murderers had been white men dressed as Indians and that the girls had been—using the appropriate term of the era—"outraged." A cave containing Indian clothing and an ample supply of bows, arrows and other assorted weapons was discovered along the Guadalupe not far from the scene of the Dowdy killings at about the same time, adding credence to this proposition. Locals theorized that much of the killing and mischief that had been attributed to roving bands of Indians was being carried out by white men masquerading as Indians. On 11 December 1878, the *Galveston Daily News* reported that "all efforts by Mexican sympathizers to claim that the Dowdy killings were not the responsibility of Mexicans have failed," clearly indicating that some still held to the opinion that the massacre was not the work of Indians.

While guarding the area, the rangers built a rock monument eight or ten feet high to mark the place where the massacre had taken place, and by some

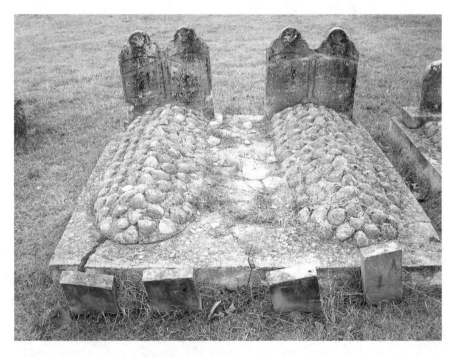

Grave of the Dowdy children. *Author's collection.*

reports smaller rock monuments were situated to mark the places where each of the children had fallen. Although Lieutenant Reynolds kept scouting parties in the field throughout the winter of 1878–79, they made no contact with hostile Indians. This, Gillett surmised, was owing to the fact that the natives rarely struck the same place twice.

The Dowdy children were buried the day after the massacre at Sunset Cemetery, located northwest of Ingram. This incident was one of the last Indian raids in Kerr County, which was largely rid of hostile Indians and outlaws that winter, thanks to the work of Lieutenant Reynolds and his men.[6]

FRANK J. EASTWOOD

Depend on the rabbit's foot if you will,
but remember it didn't work for the rabbit!

−*R.E. Shay*

A sk practically any passerby on the streets of Kerrville today to name at least one famous outlaw who ranged these hills during the late 1800s, and you are apt to be met with a blank stare. Worse yet, the clever but uninformed may proudly reply with Billy the Kid or John Wesley Hardin. In spite of some local oral histories to the contrary, Billy the Kid probably never made it this far into Texas. Tascosa, which is in the Panhandle near the Canadian River, was about the extent of his eastward travels. John Wesley Hardin did, however, pass through Kerr County on more than one occasion. But the most famed of the gangs that operated in the Texas Hill Country during the 1870s was the one led by the notorious Frank Eastwood.

Eastwood was born in Texas in about 1842. Following the Civil War, Eastwood returned to Texas and settled in the Hill Country. He was living in Kerr County during the 1870s and perhaps earlier. Eastwood's name can be found on the 1870 Census in Precinct 3 (Comfort), residing with the James Johnson family. Some sources report that both Eastwood and Johnson had served in the Civil War in the First Regiment Texas Cavalry on the side of the Union. Both James Johnson and Frank Eastwood did actually serve in that unit.[7]

Like so many returning soldiers, Eastwood began a life of crime almost immediately after the Civil War. He was indicted for theft of a mare in Williamson County as early as 1867. During 1870, he was indicted in Kerr County on numerous charges, including theft of a steer, illegally branding and driving livestock and shooting of cattle. He was also wanted in Gillespie County on nine charges of cattle theft during 1870 alone. By 1872, Eastwood was actively forming his gang, drawing new outlaws to the Kerr County area from all over the state. Among the several hideouts the band used during that era was a large, secluded cave in the rock bluff conveniently located along Johnson Creek, just a few miles above Ingram. Their nefarious activities ranged as far afield as Junction and Austin, and the gang is said to have numbered as high as nineteen at its zenith.

Feeling pressure from local law enforcement, the gang moved to Kendall County near the end of 1871 or the beginning of 1872. In 1872, a posse under the command of Nimrod J. Miller located gang member Bill Bell. Bell was wanted for murder in another county. Miller ultimately shot and killed Bell, but his death did not deter the likes of Bill Longley and the Ake brothers (Jesse and Bill) from filling the vacancy and joining Eastwood's crowd.

On 14 July 1873, the band traveled through Kerrville while being pursued by Sheriff James J. Finney of Mason County and his collection of possemen. Kerr County sheriff John M. Tedford joined Sheriff Finney, and together they caught up with the Eastwood Gang about thirteen miles from Kerrville. The posse approached the gang at dusk and wisely decided to hide out in the brush and wait until daylight, at which time they plotted to descend on the bunch. By so doing, they hoped to avoid the potential of injury or death to any of their possemen. On the morning of 24 July 1873, after patiently waiting all night as planned, the posse members executed their well-contrived plan. They descended on the encampment at dawn and arrested Frank Eastwood, Bill Longley, John Jamison, George DeGraffenreid, James Ratliff and Jesse and Bill Ake. Miraculously, they managed to do this without incident.

The entire covey of outlaws was escorted to the jail in Kerrville, where the gang members remained for less than a week. On 29 July 1873, in the early hours of the morning, a mob of angry citizens overpowered the sheriff and his deputies and took all of the men except Bill Longley from jail. Prisoner John Jamison was shot and killed during the struggle inside the jail. Frank Eastwood's body was found the next day. He had been shot seven times and left near the mouth of Goat Creek at the Guadalupe River. The Ake brothers, Jesse and Bill, were set free. Two other gang members, George DeGraffenreid and James Ratliff, were lynched from an oak tree by the mob of vigilantes.

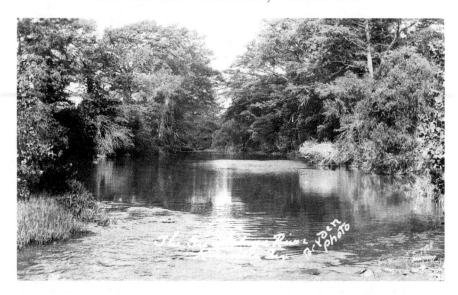

Guadalupe River, Kerrville, Texas. *Courtesy of Kerr County Historical Commission Archives.*

Some debate remains as to the exact location of the famed "Hanging Tree" involved in this incident. By most accounts it is, or was, on the property of the present-day Guadalupe RV Park. Others place its location in the Blue Bell Hills area near present-day Harper Road. Given the reference to Goat Creek as the place where Frank Eastman's body was found, it is far more likely that the oak tree would be near that area—specifically the tree location at Guadalupe RV Park.

Bill Longley, the topic of another story, remained at large until 11 October 1878, when he was hanged for murder. Frank Eastwood's fateful and final journey had ended.[8]

WILLIAM PRESTON
"BILL" LONGLEY

They who boast most, generally fail most, for deeds are silent.
—Anonymous

William Preston "Bill" Longley was the son of Campbell and Sarah Longley, born at Mill Creek in Austin County, Texas, on 6 October 1851. By April 1853, his family had moved to Evergreen, in what was then Washington County, where Longley went to school and worked on the family farm.

Tales of Longley's criminal career are an amalgamation of facts, augmented by Longley's own boastful and fictional commentary of his life of crime. What is known for certain is that at the end of the Civil War a rebellious Bill Longley took up with other like-minded young men and terrorized newly freed slaves.

On 20 December 1868, Longley, Johnson McKeown and James Gilmore intercepted three former slaves from Bell County. The three black men—brothers Green and Pryor Evans and another man known simply as Ned—had left Bell County to travel south to visit friends for Christmas. Longley and his companions proposed a horse trade with the men, but the three wisely declined and moved on. Having never genuinely considered a fair trade from the onset, Longley's group got the drop on the trio a short time later and forced the men to ride to a desolate creek bottom. Suspecting foul play, Green Evans decided to make a run for it and spurred his horse in a headlong retreat. His escape attempt drew a volley of gunshots from Longley's group. One bullet struck Evans in the head and killed him almost instantly.

Although the two surviving black men reported the incident to local law enforcement authorities, no formal charges for the killing of Green Evans were ever brought against Longley or his associates. Given the state of racial affairs in Texas at the time, this should come as no surprise.

Fact and legend become further snarled after this point in the saga of Bill Longley. He later claimed that after the Bell County incident he worked as a cowboy in Karnes County, Texas, where he killed a soldier as he rode through Yorktown. There is no corroboration for either of these claims. Longley also asserted that he rode with the notorious bandit Cullen M. Baker in northeast Texas. That declaration is also unlikely, and no substantial evidence has surfaced to support the claim.

In 1869–70, Longley surfaced in south-central Texas. There he and his brother-in-law, John W. Wilson, were busy terrorizing residents. It is alleged that in February 1870 they killed a black man named Paul Brice in Bastrop County. The pair were also accused of killing a black woman, but no evidence to support that allegation has ever surfaced.

In the aftermath of the Civil War, the racial tensions in Texas ran high for many years, fueled in large part by the heavy-handed postwar governing of Texas by Union appointees and northern transplants—often called carpetbaggers. Battles between proslavery and antislavery factions raged, especially in the Piney Woods country of east Texas. Blacks were fair game and often preyed on by unscrupulous Anglos lacking cultural capital. More often than not, crimes against blacks were not reported for fear of reprisal. On those rare occasions when blacks did seek the protection of the law, their claims were often dismissed, ignored or discredited.

In March 1870, the military authorities offered a $1,000 reward for Longley and Wilson, describing them as murderers and horse thieves. When captured some years later, Longley later claimed that Wilson was killed and buried in Brazos County in the spring of 1870. There is, however, evidence that Wilson was killed in Falls County in 1874. The inconsistency is not surprising given Longley's record of rewriting history.

After Wilson's death, Longley traveled north. He later claimed that he killed a trail driver named Rector, fought Indians, killed a horse thief named McClelland and killed a soldier at Leavenworth, Kansas, for insulting the virtue of a Texas woman. None of these claims has been validated. At Cheyenne, Wyoming Territory, Longley joined a gold mining expedition into the Wind River Mountains but was stranded when the United States Army stopped the group's mining activities. On 22 June 1870, he enlisted for five years as a trooper in Company B of the Second Cavalry Regiment,

stationed at Camp Stambaugh in the mountains near the mining towns of South Pass and Atlantic City, located along the old Mormon Trail on the Continental Divide.

The primary duty of the troops at this new post was to scout the area for bands of Indians, who presented a continuing threat to the miners and the community. Longley quickly found that military life was not to his liking and deserted after only two weeks of service. He was soon captured, returned to the post and court-martialed.

After pleading guilty, Longley was sentenced to two years at hard labor. He began serving his sentence in the newly built stockade at Camp Stambaugh. Four months later, in December, when a harsh winter gripped the post and driving snows produced twenty-foot drifts, his company commander took pity on him and released him to resume his military duties.

Longley was recognized as a skilled marksman and thus became a regular member of hunting parties that scoured the mountains for game to feed the men at the post. In a 2002 article written by Rick Miller and published in *Wild West* magazine, the author penned that one particular sergeant recalled Longley as "an idle boaster, a notorious liar and a man of low instinct and habits, but tolerated on account of his good nature, gift of gab, and excellent marksmanship." Longley, however, would later deny that he had ever been in the U.S. Army and falsely claimed that he had been a teamster and had killed an officer with whom he shared a kickback scheme.

Longley tolerated army life in the mountains of Wyoming for only another eighteen months. In June 1872, he deserted, this time for good. Where he went or what he did during the intervening six months is not known, but he turned up in Texas in February 1873.

Now back in Texas and up to his old habits, he is reported to have murdered a black man named Price in Brown County. In July 1873, he was known to have been in Bell County, where his parents had moved. In Brown County, he was spotted carrying a pistol, which was illegal. Amazingly, he was indicted for that somewhat trivial violation. At about this same time, he was accused of engaging in a gunfight in the Santa Anna Mountains in Coleman County. Perhaps he was in both places at the same time, or perhaps the oral history of these two events is inaccurate. Nonetheless, the line between fact and legend in the life of Bill Longley is once again blurred.

On 14 July 1873, the notorious Frank Eastwood Gang, with Longley in tow, traveled through Kerr County. After a brief pursuit and stunningly inventive capture by the sheriff of Mason County and Kerr County sheriff John M. Tedford, the group was taken into custody and transported to

the jail in Kerrville. On 29 July 1873, not long after briefly enjoying the comforts of the Hill Country lockup, a mob of angry citizens overpowered the sheriff and his deputies in the early hours of the morning and took all of the prisoners—except Longley—from jail. Two of the men were lynched. Frank Eastwood was shot multiple times and left along a local creek. Just why the Hill Country vigilantes decided to leave Longley in custody is a mystery. The fact that all of the prisoners were taken from the jail except Longley, who was the only one with a bounty on his head, has always raised the question of the sheriff and his deputies being complicit in his escaping the vigilante's noose.

Longley, who was correctly identified by Kerr County sheriff Tedford as being wanted for murder, was taken to Austin by Mason County sheriff J.J. Finney. Finney hoped to claim any reward. When the State of Texas denied payment of the bounty because it had been offered by the military government during Reconstruction, Finney apparently decided to just release Longley. Some have also claimed that he did so in exchange for payment by one of Longley's cousins.

In late 1874, Longley and his fifteen-year-old brother, James Stockton Longley, rode from Bell County to the Lee County home of their uncle, Caleb Longley. Uncle Caleb implored Longley to kill a man named Wilson Anderson for allegedly killing his son, "Little Cale"—whose death is thought to have been accidental because the incident took place while "Little Cale" and Anderson were quite intoxicated, and Cale recklessly rode his horse into a tree.

Uncle Caleb Longley was, nonetheless, intent on exacting revenge. Bill's brother, Jim, tried to get Bill to let Uncle Caleb do his own killing, but on the afternoon of 31 March 1875, the two Longley brothers rode over to Anderson's farm, where they found him plowing in the field. Bill Longley rode up to Anderson and told him that he was going to kill him. Next he made good on that pronouncement by shooting him twice with a shotgun. Bill and Jim then rode off, eluding the posse that was quickly organized to pursue them. Bill Longley and his brother Jim then rode north to the Indian Territory (present-day Oklahoma).

The pair quickly became homesick and, predictably, returned to Texas. During their journey home, they spent a short time locked up in jail in the small town of Van Alstyne in Grayson County but soon returned to Bell County in July 1875. Bill's stay in Bell County was brief. Jim was arrested for the murder of Anderson but was later acquitted. Bill evaded capture, and another reward was added to the one that had previously been offered for his capture.

Longley next rode north to Waco in McLennan County, where he used the name Jim Paterson and took a job at the farm and cotton gin of John Sedberry. Along with a newly found companion, Robert Rushing, he is said to have engaged in occasional robbery and assault.

On the cool and crisp evening of 13 November 1875, he took part in a drunken fox hunt during which he managed to get into an argument with a young man named George Thomas. The argument soon led to a fistfight that escalated into a gunfight. Longley managed to acquire a six-shooter from someone in the group and proceeded to shoot Thomas three times. The wounds were fatal. He was indicted for the shooting but promptly stole a horse and left the county.

Longley next surfaced in Uvalde County, in the Dry Frio Canyon, sometime late in 1875 or early January 1876. He had now chosen a new alias: Jim Webb. In the Dry Frio Canyon country, he met William "Lou" Shroyer, a Pennsylvania native and former Union soldier who also had a reputation as a bad hombre.

Shroyer suspected Webb's true identity and is said to have conspired to capture or kill Longley for the reward. When Longley learned of the plot, he somehow managed to get himself deputized by the Town of Uvalde to arrest Shroyer in connection with the scheme. Accompanied by a deputy named William Hayes, Longley returned to the Dry Frio Canyon to formulate a plan for dealing with Shroyer.

By 10 January 1876, Longley and Hayes had launched their hastily conceived plan. The pair told Shroyer that they had killed a cow and suggested that he share in some of the meat. Shroyer agreed, bringing with him a pack of dogs that he kept. Longley's idea was to get the drop on Shroyer as they rode to the spot where the cow was located. During the course of the journey, Shroyer sensed trouble. When he spotted Longley and Hayes drawing their pistols, he raced away, leaving the two would-be assailants behind. Longley and his companion quickly racked out in pursuit.

In the hail of gunfire that followed, one of the pair shot Shroyer's horse. Shroyer returned fire and managed to kill Longley's horse before retreating into a stand of trees to take cover. The horse killers now faced off. During the gun battle, Shroyer managed to shoot Hayes in the thigh. Hayes's horse spooked and ran off, with the injured rider aboard. Now the fight was down to just Shroyer and Longley. The two traded shots until, finally, Shroyer called out that he wanted to talk to Longley. Longley walked toward him, and according to Longley, "Lou" Shroyer raised his weapon as if to shoot. At that point, Longley killed him. Given that the only surviving witness to the

encounter was Longley himself, one must question the veracity of his claim of self-defense.

On the move again, Longley fled Uvalde County. By mid-February 1876, he was at the other end of Texas, in Delta County, east of Dallas. Now going by the name of William Black, he stayed with a farmer named Thomas P. Jack in the small community of Ben Franklin. Not long after taking up residence at the Jack farm, Longley became romantically interested in the farmer's sixteen-year-old daughter, Rachel Lavinia, who was called "Miss Louvenia."

Longley decided to remain in the community and entered into a sharecropping arrangement with a farmer and part-time preacher named William Roland Lay. To his dismay, he discovered that he had a rival for Miss Louvenia's affections. The other suitor, a young man named Mark Foster, was Mrs. Lay's nephew. This, not surprisingly, led to complications with the Lay family. Eventually, Longley forced a confrontation with Foster and whipped him soundly with a quirt and a pistol.

Charges of false imprisonment were made against Longley, who was at the time still using the name William Black, and on 6 June 1876, he was jailed at Cooper, the Delta County seat. Six days later, he burned a hole in the jail door and escaped. Blaming Reverend Lay for his predicament, Longley armed himself with a shotgun and took up a post at the Lay farm, waiting for an opportunity to settle the matter with the preacher. As dawn broke, Longley crept up on Lay, who was at the time calmly milking a cow, and shot him without warning. Once again Longley fled.

Precisely where he went and what he did next remains a bit of a mystery. Some report that he freed two Lee County desperado friends named Jim and Dick Sanders from the custody of a Grayson County deputy sheriff. The three of them are said to have ridden south toward Lee County and, while on their journey, disarmed a Milam County deputy named Matt Shelton.

In the spring of 1877, Longley adopted a new alias: Bill Jackson. One cannot help but note that most of the time when Longley selected a new pseudonym, he chose the given name Bill or William—not terribly imaginative. Longley took a job working for a farmer named W.T. Gamble near Keatchie in De Soto Parish, Louisiana. Soon he became friendly with the local constable, June Courtney. Courtney, however, had come across a circular from Texas describing a wanted man named Bill Longley, whose description seemed to match that of his newfound friend Bill Jackson. The constable contacted Sheriff Milt Mast in Nacogdoches County, across the Sabine River in Texas. Mast sent a letter to the Lee County district clerk,

W.A. Knox, asking for more particulars. When Knox provided a letter dated 18 May 1877, he commented that "Longley is today the worst man in Texas...You will have to take the advantage of him—he will fight and is a good shot."

Sheriff Mast and his deputy, Bill Burrows, consulted with Courtney and formulated a plan to apprehend Longley. On 6 June 1877, Courtney asked Longley to come to his house and accompany him while making an arrest. The unarmed Longley was promptly surrounded by the three lawmen, placed in restraints and transported back to Texas. Within days, he was in the Lee County jail, where he was held for the 1875 murder of Wilson Anderson. From jail Longley began to promote himself as the deadliest gunfighter in Texas. He boasted that he had killed a total of thirty-two men. He was primarily competing for the title of most dangerous outlaw with gunman John Wesley Hardin, who was eventually captured in Florida in August and who had reportedly killed twenty-eight men. Longley claimed that although he had killed men, he had never ridden with horse and cattle thieves, nor had he ever stolen anything. Of course that was far from the truth.

The trial for Longley was set for 3 September 1877 and was to take place in a temporary courthouse in Giddings. Sheriff Brown had recruited a strong guard to foil any attempts that might be made at rescuing the prisoner. It took only one day for the prosecution to present its case, and the jury took just an hour and a half to return a verdict of guilty of murder in the first degree. The sentence was death for Bill Longley. He was soon transferred to the Galveston County jail pending the outcome of the appeal of his death sentence. There he made a feeble and unsuccessful attempt at escape in early March 1878. On 13 March, the court of appeals affirmed Longley's conviction, finding that his trial had been just and fair. In July, while waiting for court to convene in Giddings so that he finally could be sentenced, he converted to Catholicism. A petition effort was mounted in Nacogdoches asking that the governor commute his sentence to life. An uncle in California sent a letter to President Rutherford B. Hayes asking for a presidential pardon. Bill Longley was returned to Giddings in August, and on 6 September he was sentenced by District Judge E.B. Turner to be executed on 11 October.

As dawn broke on the morning of Friday, 11 October 1878, it promised to be a gray, gloomy day. There was a threat of rain in the air. Thousands of people traveled to the small community of Giddings to see Bill Longley's hanging. He dressed in a black suit, with a white shirt and black tie and a broad-brimmed, low-crown hat. On his lapel he wore a blue rosette

arrangement, and beneath his shirt hung a small Catholic medal on a thin cord. Only one family member, a ten-year-old niece, visited him. When he kissed her goodbye, even the strongest hearts in the jail were touched.

Shortly after noon, Sheriff Brown took Longley on a slow ride to the waiting gallows. Heavily armed guards escorted the wagon on foot. Guards on horseback intently watched the massive crowd. At 2:15 p.m., the sheriff, Longley and others began to mount the scaffold. Longley stood as Sheriff Brown read the death warrant. Longley then discarded the cigar he had firmly clenched in his teeth and briefly addressed the crowd, atoning for his evil deeds and asking forgiveness. The crowd watched as the hangman performed the act. Longley dropped through the gallows' trapdoor and hit the ground, neck sore but not dead. The hangman had used the wrong rope length for the job. To the crowd's, and Longley's, astonishment he would have to be hanged twice. Again the latch was released, and Bill Longley dropped from the execution platform. This time his death sentence was carried out—or was it?

As is the case with so many notorious outlaws, there are those who insist that somehow Longley cheated death and lived another day. For dreamers and mythmakers, the truth is never enough. Just as in the case of Billy the Kid, rumors persisted for years that Longley's hanging had been a hoax and that he had gone to South America. A claim was made in 1988 that he had reappeared and had died in Louisiana.

Between 1992 and 1994, an effort was made to find his body in the Giddings Cemetery. The undertakings came to naught. Finally, in July 1998, using a computer to match up the old photo of his burial with new photos of the cemetery, the spot was located where the older photograph must have been taken. An excavation of that site revealed the skeleton of a Caucasian man fitting Longley's physical description. Forensic science revealed that the man had suffered from periodontal disease, as well as a broken leg, which was perhaps the result of the fall from the scaffold. The most eerie evidence yielded by the examination of the remains was a Catholic medal that had been worn around the man's neck on a cord. Also found was a small piece of artificial material with the design of a leaf that could have been from the rosette Longley wore.

The remains were taken to the Smithsonian Institution in Washington, D.C., for DNA testing and skull reconstruction identification. In June 2001, it was announced that the remains were indeed those of Bill Longley. His bones were subsequently reinterred in Texas, providing an end to his story at long last.[9]

A Vast Array of Outlaws

I t has been claimed by some that no fewer than three thousand outlaws and badmen were rounded up or brought to their just end in Kerr County before 1900. On 24 July 1873, the *Galveston Daily News* reported that "the citizens [of Kerr County] have taken the law into their own hands and have killed about twenty outlaws." On the same day, this newspaper reported the capture of the notorious Ake brothers, charged with murder and other crimes. For some unknown reason, Jesse and Bill Ake were set free on 29 July 1873 by a mob of angry citizens that took Frank Eastwood from the same jail and murdered him near Goat Creek. Again on 23 September 1873, the *Galveston Daily News* reported that "[t]he special dispatch from our San Antonio correspondent depicts an alarming state of affairs in Kerr County. For three months or more now our columns have contained reports of the most flagrant outrages committed by a band of outlaws on peaceable residents of that section. The citizens of Kerrville have organized time and again against this gang, and have followed them into the mountains several times and shot and hanged a number of them."

Conditions in Kerr County deteriorated to the point that federal troops were dispatched to help maintain order. Not everyone supported that extreme measure, and on 28 September 1873 the *Galveston Daily News* reported that the *State Gazette* deprecated the actions of the officials of San Antonio for sending federal troops to Kerr County, claiming that it was unconstitutional and that the law provided adequate state remedies to suppress those disturbances.

Fortunately for Kerr County residents, the government officials paid little attention to the *State Gazette.*

Although the earlier cited claim of three thousand outlaws having been apprehended, or otherwise disposed of, may sound lofty to some, on balance historians have little reason to doubt the veracity of the assertion. It is a fact that many of the legendary Texas badmen beat a path through Kerr County. Familiar names like John Wesley Hardin, "Gip" Hardin, Frank Eastwood, Bill Longley, Scott Cooley, John Ringo, the Dalton Gang and many more traveled the cypress-lined trails bracketing the Guadalupe River. It was, however, the less famous riffraff who contributed so greatly to the folklore of the region.

Newspaper accounts of the day are often inaccurate, with details sketchy at best, when it comes to reporting the evil deeds of some of our citizens and undesirable visitors. For example, on 20 November 1872, the *San Antonio Herald* reported that a man named "McWeston" was killed "a day or two since" at Kerrville by a man named Spencer. The unfortunate man who was identified incorrectly as McWeston was actually Malachi M. "Mac" Weston. He arrived at Kerrville sometime after the 1870 census since he does not appear on that record. Weston is buried at the Mountain View Cemetery in Kerrville. Since there were no follow-up reports, it is likely that we will never know the reason for the crime nor the fate of the perpetrator, Mr. Spencer. There was no one named "Spencer" living in Kerr County at the time, and since there were no less than 346 men named "Spencer" living in Texas in 1872, it's unlikely that we will ever learn the true identity of Mac's killer.

On 13 June 1875, five robbers from Leon Springs proceeded to Comfort and stole two horses from the stage livery, later passing through Kerrville about noon on Monday, 14 June 1875. While in Kerrville they stole two more horses. Captain Schreiner assembled a few Minute Men from his former company and gave chase. The posse came upon the thieves forty miles above Kerrville and demanded their surrender. The robbers replied by firing at the Minute Men and took to the bush on foot, leaving the horses behind. Schreiner's men returned fire, wounding one man, killing one of the stage horses and capturing ten of the remaining stolen horses. The wounded man was said to have been mortally hurt and was not expected to survive. The Minute Men expressed confidence that they would catch up with, and apprehend, the balance of the outlaws since they were strangers in this section and would not know where best to hide.

In another incident, a man named Joe Riley was indicted for cattle theft by a Kerr County grand jury on 28 September 1877. Riley was being held

pending bail in the amount of $250, a handsome sum for an 1877 criminal to produce. One can only speculate that perhaps the beeves of someone notable like old Captain Schreiner might have somehow found their way into Mr. Riley's stock pen?

Although Kerr County was largely free of outlaws during the winter of 1878–79, one truly bad hombre remained at large: Eli Wickson. Wickson, incorrectly spelled "Wixon" by Texas Ranger James B. Gillett in his report, was wanted for murder in east Texas and came to the Kerr County area from Milam County. His father hailed from Ohio and had been among the early settlers of Texas, having been granted a First Class deed to 1,476 acres in Washington County in 1841. His mother, Charity, was from Georgia. Eli had four brothers (John, Robert, James and Peter) and three sisters (Emeline, Aramintha and Margaret).

Expecting trouble from Wickson at the polling place for the November 1878 election, Texas Ranger Lieutenant N.O. Reynolds sent five rangers to monitor the proceedings. The group consisted of Corporal J.W. Warren, Private Will Banister, Charles L. Ware, Private Abram Anglin and an unidentified fifth ranger.[10] The men were dispatched to a site that was located about sixteen miles west of Kerrville at the Eller School and were tasked with making certain that law and order were maintained.[11] In due time, Corporal Warren spotted Wickson. He approached him and ordered the man to drop his cartridge belt and pistol. Wickson first hesitated and then refused. He called on the crowd of locals to come to his aid, and for a time it seemed that they would. In spite of the abusive language hurled at the rangers by Wickson, and the crowd collectively, Corporal Warren stood his ground. The rangers placed Wickson in handcuffs and shackles, and Corporal Warren made it clear to the crowd that if any trouble started, Mr. Wickson would be the first one to be shot. Privates Banister and Anglin held the crowd at bay with drawn Winchesters while the corporal disarmed Wickson, grasped the reins of his horse and led him away. Wickson was turned over to the custody of the sheriff at Kerrville on 6 November.

Eli Wickson was born 17 February 1843 and died 29 July 1924. He was the son of Dyrun and Charity Francis "Fannie" Wickson of Milam County. Eli had four siblings: older brother John, younger brothers Robert and James and sister Emeline. By 1860, it seems that Dyrun Wickson had passed, and the 1860 census shows a Lemuel Bass as head of the household. By 1870, Eli had moved to Maysfield, Milam County. From the records it appears that Eli probably killed his stepfather in 1870 or 1871. The Milam County Courthouse burned down in 1874, destroying most of the records, thus all

we have to rely on are newspaper accounts that make that claim. The case against Wickson was reinstated on 3 May 1880 as #1915 and was called several times during 1883. Wickson must have escaped from authorities sometime after his arrest in Kerr County in 1878, as he is indicated as being a fugitive in 1886. The remainder of his life is something of a mystery, but it is clear from the foregoing account that he was unsuccessful at his attempt to disrupt the November 1878 elections in Kerr County.

On 14 January 1885, Kerr County sheriff Frank M. Moore delivered Andrew "Andy" Elam to the Dallas County jail and collected a $100 reward. Elam, a resident of Kerr County, was using the alias "Andrew Anderson." Andrew J. "Andy" Elam, born in Texas in 1846, had begun his life of crime some years earlier. Newspaper accounts of the day indicate that he was charged with theft of hogs on 1 November 1877. Elam was indicted for assault with the intent to commit the murder of Andy Bergman and Dick Douglas and for the theft of horses belonging to Bergman. He jumped bond, of which there were several ranging from $700 to $1,000.

Andy Elam had stolen Bergman's horses and then shot him with buckshot (albeit not fatally) at Bergman's home. Elam and a man named Jim Hunnicutt were indicted for that shooting. A black man named Douglas, who was a witness to the Bergman shooting, was fatally shot not long after while he was cleaning up the Stockyard Saloon after hours. Both Andy Elam and Jim Hunnicutt were indicted for that murder. The Douglas killing was soon followed by another murder that was probably the work of Elam and Hunnicutt. A man named F. Lee "Frate" Humphries, a witness to the Douglas killing, was also killed at the Stockyard Saloon. The incident took place at 1:00 a.m. on 17 June 1884. Hunnicutt was indicted for that murder as well, although a man named Joe Polsar, who was an ex-convict, had given himself up to the constable and confessed to the killing. Humphries made a deathbed statement that it was Hunnicutt who had shot him. Both Humphries and Hunnicutt were known members of the Scyene Gang, as was Andy Elam.

Scyene was a small town in east-central Dallas County, Texas, located about ten miles east-southeast of downtown Dallas. Scyene was officially established in 1854 when a post office was built in the city. Before that, the town had been called either Thorpville or Prairie Creek. James Beeman suggested the town name, with the spelling of "Seine," but residents first spelled it "Sceyne," which eventually evolved into Scyene.

In days gone by, Scyene was acknowledged as having the gayest and most rollicking set of boys in the county, barring the Bear Creek neighborhood.

Belle Starr made Scyene her headquarters during her girlish days. It was probably Belle's dashing style that first inspired the boys around Scyene to "be not like dumb driven cattle." The town was also notable for such residents as Jesse and Frank James, as well as Cole and Bob Younger. At its zenith, in 1873, Scyene had a population of about three hundred, a Masonic Lodge, a wagon factory and, of course, six saloons. That same year, however, the Texas and Pacific Railway bypassed the town, causing a slow decline of the town.

The surname "Elam" seemed to be an unfortunate one hereabouts. A black man named William Elam was apprehended for criminal assault on a ten-year-old schoolgirl and daughter of a prosperous rancher at Devine Station (Devine) in nearby Medina County on 6 November 1891. He was lynched by an angry mob the next day.

Next there is the story of Phillip G. "Doboy" Taylor, who met his end in Kerr County. Taylor was a notorious gunfighter and son of the legendary Texan Creed Taylor (1820–1906). Creed Taylor was a celebrated soldier and Texas Ranger, born on 20 April 1820 in Alabama. He was one of nine children of Josiah and Hepzibeth (Luker) Taylor. Josiah Taylor, a relative of General Zachary Taylor, came to Texas in 1811 and served as captain in the Gutiérrez-Magee expedition. He fought at La Bahía, Alazán, Rosales and Medina. Taylor brought his family, including four-year-old Creed, to Texas in 1824 and settled in DeWitt's colony. At fifteen, Creed helped defend the Gonzales "come and take it" cannon and took part in the Battle of Concepción, the Grass Fight and the Siege of Bexar. Late in January 1836, he was with the Texas forces at San Patricio. He was placed on detached duty as a scout or courier until 1 March 1836, when he was ordered to join Colonel James C. Neill in Gonzales.

After the fall of the Alamo, Taylor led his mother and family to safety in the Runaway Scrape. He caught up with the Texas army at Buffalo Bayou on 20 April and fought in the Battle of San Jacinto. In 1840, Taylor took part in the Battle of Plum Creek against the Comanches with Daniel B. Friar's Company. In 1842, he joined the Texas Rangers and fought Indians with John Coffee Hays at Bandera Pass. The following year, he was wounded in the Battle of Salado Creek. In the Mexican-American War, he enlisted as a private in Captain Samuel H. Walker's Company of Texas Mounted Rangers that mustered into federal service on 21 April 1846. Taylor fought at the Battles of Palo Alto, Resaca de la Palma, Monterrey and Buena Vista. He enlisted in the Confederate army on 13 February 1864 in Colonel John S. "RIP" Ford's command.[12] Taylor married Nancy Matilda Goodbread on 25 April 1840,

and they became the parents of two sons and a daughter. After wife Nancy died in 1867, both of his sons, Phillip and John, became outlaws and were deeply involved in the Sutton-Taylor feud, the most lengthy and bloody in Texas history. Creed Taylor died on 26 December 1906 at the age of eighty-six and is buried at Noxville, Texas, in the old cemetery off County Road 473.

The story of Creed Taylor is one of the often neglected sagas of men who truly personify the rugged old breed of Texas pioneer. He took part in many of the major events of early Texas history, and unlike most of his counterparts, he lived to tell about them. Later in life, Taylor settled along the Little Devils River about ten miles northwest of Harper. He built a stone house there in 1869. Other settlers came in the 1870s to settle nearby, although Taylor was Noxville, Texas's first resident. In 1879, a storekeeper named Nox, for whom the town was named, opened the town's post office. The Noxville school was the first stone school in Kimble County. In 1940, the school merged with the Harper Independent School District in Gillespie County. In 1911, the post office was moved west to the James River. By the 1920s, the town had grown to include a store and gas station. The post office closed its doors in 1942 when the population was fifteen or less. By 1990, it had declined to only three people.

One of the early difficulties involving the Taylors occurred in 1866 regarding two killings. Creed's son, Buck Taylor, shot and killed a black sergeant who came to a dance at Taylor's uncle's home. Not long after, Hays Taylor, Doboy's brother, shot and killed a black soldier in an Indianola saloon. In November 1867, brothers Hays and Doboy Taylor were involved in the killing of two Union soldiers at Fort Mason. Union soldiers were said to have been harassing them, and when one of the soldiers knocked Hays's hat to the ground, he calmly drew his pistol and shot the man. More soldiers quickly gathered around the Taylor brothers, attempting to arrest them, but a gunfight broke out, and the Taylors shot and killed a sergeant before fleeing the town. The pair got away and returned to their father's ranch in Karnes County.

In March 1868, Deputy Sheriff William Sutton led a posse from Clinton in DeWitt County in pursuit of a gang of horse thieves. They caught the men on the street in Bastrop, killed Charley Taylor and captured another man named James Sharp. Unfortunately, Sharp did not make it back to Clinton. He was shot and killed by Sutton's men on the journey home as he was trying to escape. The often violent animosity between the Sutton and Taylor factions resulted in another famous Texas feud, appropriately called the Sutton-Taylor feud. This vendetta eventually led to many more deaths.

According to the Taylor family (Creed and Pitkin and their sons), the real beginning of the feud was the killing of Buck Taylor and Dick Chisholm at the town of Clinton in DeWitt County on Christmas Eve in 1868. Buck had charged Sutton with dishonesty in connection with the sale of some horses, and shooting soon resulted. The feud evolved into a protracted struggle between the Taylor party and Edmund J. Davis's state police captain, Jack Helm. Helm was backed by Jim Cox, Joe Tumlinson and William Sutton—whose views were in sharp conflict with the strong-minded southerners of the region. General Joseph Jones Reynolds was responsible for civil and military affairs in Texas and appointed a man named C.S. Bell to oversee a group of law enforcers called the "regulators." Jack Helm, appointed as a "regulator" by Bell, later claimed that his duties were there to "assist in arresting desperados." Professing to be in pursuit of horse and cattle thieves, the state police under Captain Helm terrorized a large portion of southeast Texas.

On 23 August 1869, a posse laid an ambush that resulted in the death of Hays Taylor. The Taylor brothers were riding in the early morning hours near their father's ranch. Led by Jack Helm, the group of possemen opened fire on the pair from ambush. Jack and Doboy fought back. When the smoke cleared, Doboy was wounded in the arm but was able to escape. Brother Jack Taylor was killed, but not before he had shot five of Helm's possemen in the heated gun battle.

The worst outrage was the assassination of Henry and William Kelly, sons-in-law of Pitkin Taylor, which occurred on 26 August 1870. The Kellys were arrested on a trivial charge, taken a few miles from home and shot down like dogs, while their mother, Mrs. Henry Kelly, watched from hiding. Helm was dismissed from the force when other examples of his misconduct came to light, but he continued to serve as sheriff of DeWitt County. After Helm's demotion from the state police, Sutton began to be recognized as the leader of the party.

Phillip "Doboy" Taylor was again attacked the following month, on 7 September, when he was at the house of a friend. As Phillip and two friends named Kelleson and Cook were leaving the home of William Conner on the Neches River, Sutton Regulators ambushed them. Kelleson was killed, but Taylor and Cook retreated and fought back. They soon ran out of ammunition and were forced to surrender. Amazingly, they were not killed and were able to escape that evening. The next time, Phillip "Doboy" Taylor would not be so lucky. As a result of a chance encounter in Kerrville, with a man named Sim Holstein, Doboy Taylor would miss the remainder of the Sutton-Taylor feud.

An example of the clever but underhanded tactics used by the feuding parties can been seen by reviewing an incident that resulted in the shooting of Pitkin Taylor in the summer of 1872. A party of Sutton sympathizers lured Pitkin from his house one night by ringing a cowbell in his cornfield. Pitkin, an old man by now, was shot and severely wounded. He died six months later. At his funeral, his son, Jim Taylor, and several of their relatives resolved to avenge his death. Their first attempt to discharge this oath was made on 1 April 1873 when they caught William Sutton in a saloon in Cuero. They fired through the door and wounded him. They next ambushed him in June 1873, but that time he escaped without injury. In June or July, the Taylor boys waylaid and killed Jim Cox and another member of the Sutton group. A little later, Jim Taylor and John Wesley Hardin killed Jack Helm in a blacksmith shop in Wilson County. The day after Helm's death, a strong force of Taylors moved on Joe Tumlinson's place near Yorktown. After a brief siege, the sheriff and a posse appeared and talked both parties into signing a truce, but the peace lasted only until December, when Wiley Pridgen, a Taylor sympathizer, was killed at Thomaston. Enraged by this murder, the Taylors attacked the Sutton faction, besieged them in Cuero for a day and night and were themselves besieged in turn when Tumlinson appeared with a larger band of Suttons.

By this time, the county was in terrible chaos. Residents had little choice but to choose sides. William Sutton moved to Victoria, Texas, and finally decided to leave the country. He had just boarded a steamer at Indianola on 11 March 1874 when Jim and Bill Taylor rode up to the dock and killed him and his friend, Gabriel Slaughter. The Suttons got even by lynching three Taylors. Kute Tuggle, Jim White and Scrap Taylor were among a group of cowboys who had been engaged to take a herd up the trail for John Wesley Hardin. At Hamilton, they were arrested and charged with cattle theft. They were soon brought back to Clinton, and on the night of 20 June 1874, they were taken out of the courthouse and hanged.

Most believe that the three were probably innocent of any wrongdoing. Texas Ranger captain Leander H. McNelly was called in after this event. He tried unsuccessfully for several months to break up the feud. The most notable events of the next few months included Bill Taylor's escape from confinement at Indianola as a result of the great storm of 15 September 1875; the assassination of Rube Brown, who was the new leader of the Suttons and marshal of Cuero; and the fight in Clinton on 27 December, during which Jim Taylor and two of his friends were killed. With the death of Jim Taylor, the Sutton-Taylor feud more or less came to an end. The

Suttons, many of whom were peace officers, had things pretty much their own way. However, they soon became involved in difficulties that were clearly a legacy of the feud. Several of them were implicated in the murder of Dr. Philip Brassell and his son, George, at their home near Yorktown on the night of 19 September 1876. This deed aroused the greatest indignation, and Judge Henry Clay Pleasants asked Lieutenant Jesse Leigh Hall to bring in the rangers. Eight men were charged with the crime and held for trial. A series of legal maneuvers lasting over twenty years resulted in only one conviction, and that person was eventually pardoned.

As for the fate of Philip "Doboy" Taylor, who missed much of the fight, he was in Kerrville, Texas, in November 1871 and lobbying for a job working for a New York cattle firm as an agent. This might sound like a responsible thing, but the job belonged to another man named Simpson "Sim" Holstein at the time. Holstein was a cattle drover and a rough character by all accounts. He was born in Louisiana in 1847 and had most recently lived in Gonzales, Texas. One afternoon, Doboy Taylor called Holstein out of the Pruitt Hotel at Washington and Water Streets in downtown Kerrville and threatened him.[13] The discussion soon turned into a quarrel. Taylor pulled his pistol and threatened Sim. Sim leaped a low gate and grappled with Taylor. Taylor fired his pistol and missed. Sim Holstein then tore the gun out of Taylor's hand and shot him with it. Taylor, hit at close range, fell to the ground but soon stood up. Sim fired a second time, once again dropping Taylor like a sack of feed on the city street. Miraculously, Taylor rose again and was shot a third time by Holstein. After the third shot, Taylor staggered away, calling for help. He died from the multiple gunshot wounds about six hours later.

As is the case with so many personalities who briefly cross the stage during the saga of the frontier West, little is known of Simpson Holstein. There is, however, an account in the *Dodge City Times* of 9 June 1877 that provides a bit more insight:

> *The fastidious Col. Norton fell next. He ranks next to Bat Masterson in point of courage, being somewhat more cautious and much more inclined to make a bloodthirsty talk. He is said to be tolerably handy with his gun, and fair to middling at shoulder hitting. Norton had been accused of ways that were dark and tricks that were vain in a poker game, by a Texan, and several other Texas men took a hand in the game of talk which followed. Norton soon discovered that the gang was oversized, and amiably went against the booze joint for the house. But the flowing bowl raised his courage above all cautionary measures and he gave it out solid that he*

was a fighter and thirsted for blood. Sim Holstein, a cattle drover, quietly gave it as his opinion that Mr. Norton couldn't fight very much; that there were several men in town he could not lick—Sim himself, for instance. A lightweight drover by the name of Lee then interfered and claimed the fight for himself. Norton and Lee then had a little scuffle, which was soon interrupted by the police. Larry soon after espied Norton in a crowd recommending himself as a fighter, and ordered him to disperse. Norton proudly reminded Mr. Deger that he was a sovereign citizen of Dodge City, and as such had certain inalienable rights. For answer Mr. Deger promptly marched him to the doghouse.

Then there is the following account of Holstein in the book *Texas Trail Drivers*:

Good trail bosses who made quick time with the stock in good shape were always in demand. Ab Blocker, Gus Black, Sim Holstein, Henry Clair, Jones Glenn, Jesse McCoy, Bob Jennings and Bob Lauterday were all record breakers in taking their herds through in quick time and fine shape, but Ab Blocker claims the blue ribbon.

The Pruitt Hotel, Kerrville, Texas. *Courtesy of Kerr County Historical Commission Archives.*

It is interesting to note that Ab Blocker is known to have taken cattle up the trail to Kansas for Captain Schreiner on more than one occasion. One might speculate that Holstein might have been in Schreiner's employ as well.

In the case of "Doboy" Taylor, like so many others during the postwar Reconstruction era, we find a reoccurrence of family surnames with multiple "badmen" being the products of the same household. We also find a fascinatingly intertwined web where the lives of lawmen and outlaws seem to come together in the most unexpected ways. Such is the case with "Doboy" Taylor's 1869 encounter with Jack Helm. By means of background to this story, Jack Helm had been a captain of the Texas State Police under the command of Edmund J. Davis. He is said to have worked for the notorious Abel Head "Shanghai" Pierce as a cowboy shortly after the Civil War. In June 1869, he was appointed a special officer to assist Captain C.S. Bell in attacking the "Taylor Party" in the Sutton-Taylor Feud. Helm went to Austin and became the leading figure in the band of special officers known as Regulators. Through July and August 1869, they carried out a reign of terror in Bee, San Patricio, Wilson, DeWitt and Goliad Counties. The *Galveston News* reported that they killed twenty-one people in two months and turned over only ten to the civil authorities. On 23 August 1869, Bell and Helm arranged a second attack on Taylor's ranch in which Hays Taylor was killed and "Doboy" Taylor wounded, as earlier reported. After the founding of the state police on 1 July 1870, Helm was appointed one of the four captains. On 26 August 1870, his detachment arrested Henry and Will Kelly of the Taylor faction on a trivial charge and shot them. Helm was subsequently suspended in October and dismissed in December. He continued to be a menace for some time, serving as sheriff of DeWitt County during and after his incumbency as captain of state police. When the police force was abolished in April 1873, Helm moved to Albuquerque, Texas.

Sheriff Helm was shot and killed by John Wesley Hardin on 17 May 1873. His death is reported to have been a result of a personal disagreement. Helm is buried in the McCraken Cemetery in DeWitt County.

The memory of the Sutton-Taylor feud remains vivid to this day and is often recounted by descendants of both families. Recently, historians and authors have revisited the feud and raised new theories and speculation concerning the participants, their motivations and the details of some of the events that took place. I feel most comfortable with the foregoing, traditional interpretation and offer it here without apology.[14]

THE HARDINS

*They say I killed six or seven men for snoring. It ain't true. I only killed
one man for snoring.*

—John Wesley Hardin

E very tenderfoot historian who has studied the American West has heard
of the notorious outlaw John Wesley Hardin. The Hardins occupy a
place of honor on the long list of badmen who made their way through Kerr
County and the surrounding area.

Recognizing that scores of books have been written about John Wesley
Hardin, I will not attempt to improve on the research that has already been
done, nor the quality accounts of his life and times that have already been
penned by the likes of Leon Metz, Richard Marohn and Hardin himself.
The following brief chronicle should serve as sufficient background.

John Wesley Hardin was born in Bonham, Fannin County, Texas, on 26
May 1853. He was the son of James Hardin, a Methodist preacher. John
Wesley was named after the founder of Methodism. He was only twelve years
old when members of the Confederate army returned home after the Civil
War. Hardin developed a strong hatred for freed slaves. He killed his first
black man when he was fifteen years old and fled from home after that killing.
As he would later explain, "To be tried at that time for the killing of a Negro
meant certain death at the hands of a court backed by Northern bayonets...
thus, unwillingly, I became a fugitive not from justice, be it known, but from
the injustice and misrule of the people who had subjugated the South."

Hunt Store. *Courtesy of Kerr County Historical Commission Archives.*

Tivy Hotel. *Courtesy of Kerr County Historical Commission Archives.*

In the next few weeks, Hardin killed three soldiers who attempted to take him into custody. He then moved to Navarro County, where he became a schoolteacher. Hardin later found work as a cowboy. Next he turned his attention to gambling and tried for a time to make his living playing poker. He failed at this new profession, as well, and soon killed a man named Jim Bradley in a gambling row. It is claimed that he also hunted down and killed the judge who indicted him for that killing. Hardin's next killing took place in Kosse, Texas, where a man attempted to rob him. He later pointed out that "I told him that I only had about $50 or $60 in my pocket but if he would go with me to the stable I would give him more, as I had the money in my saddle pocket...He said, Give me what you have first. I told him all right, and in so doing, dropped some of it on the floor. He stooped down to pick it up and as he was straightening up I pulled my pistol and fired. The ball struck him between the eyes and he fell over, a dead robber."

In the fall of 1871, Hardin was involved in a cattle drive up the old Chisholm Trail to Abilene, Kansas. The drive began with Hardin shooting a white ox that had been bothering the herd. For this he had to pay $200 to the owner. Along the drive north, he killed an Osage Indian who had tried to levy a tax on the herd. Next he and his group of cowboys became involved in a gunfight at the Little Arkansas River when a group of Mexican cowboys attempted to drive its own herd past Hardin's. During the fight, six Mexicans were killed, five of them by Hardin. His colleagues assigned the nickname "Little Arkansas" to Hardin after that shootout.

In Abilene, he met the famous James Butler "Wild Bill" Hickok, who had become marshal of Abilene on 15 April 1871. For some reason, Hickok took a charitable and parental attitude toward Hardin. It is claimed that they drank and sought the company of "fallen women" together. Hickok gave Hardin advice, and it's said that he helped Hardin's friends out of some trouble they had gotten themselves involved in during their stay in Abilene. Hardin enjoyed being seen with the celebrated gunfighter, but he knew at the same time that Hickok could probably add him to his list of confirmed kills if he got seriously out of line.

There are a number of decidedly different accounts of Hardin's visit to Abilene, as well as of his encounters there with Bill Hickok. The probity of some of these stories still remains in question. It is claimed that when Marshal Hickok approached Hardin to disarm him on the streets of Abilene, Hardin handed over his pistols butt first but then performed the noted "border roll" by smoothly reversing the guns in his hands, cocking them and standing ready to shoot Hickok. Another tale from his stay in Abilene has

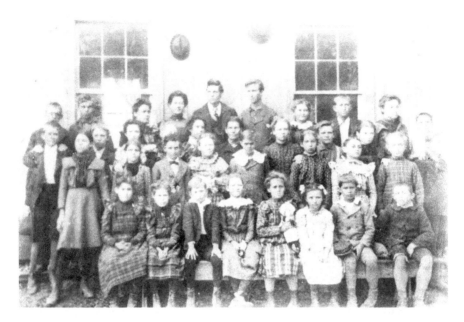

Turtle Creek School, class of 1880. *Courtesy of Kerr County Historical Commission Archives.*

Wool wagons, Kerrville. *Courtesy of Kerr County Historical Commission Archives.*

it that he shot a man in the mouth who had come into a restaurant making disparaging remarks about Texans.

While in Abilene, Hardin took a room at the American House Hotel. At about one o'clock in the morning, snoring coming from the next room awakened him. Infuriated that his rest was being disturbed, he took his pistol and fired two shots through the wall into the adjoining room. His shots found their mark, and the man in the next room lay slain. Hardin knew that he was about to be in deep trouble with Marshal Hickok. Figuring that a quick exit was the most advisable, he crawled out of his window and onto the roof above the hotel's promenade. Dressed only in his undergarments, Hardin spotted Hickok approaching from the direction of the Alamo Saloon. He leaped from the roof into a haystack, where he hid for the rest of the night. As dawn broke, he emerged, stole a horse and rode wildly out of town. There are several different accounts of the foregoing "leap from the balcony" tale. Some do not involve the shooting of an innocent snoring hotel guest but merely the fact that Hardin was wearing a gun in town, which was against local regulations at the time. The convenient placement of the haystack has always made me feel that at least one aspect of the story was contrived by some pulp fiction writer who presumed that Abilene was such a hick town in 1871 that haystacks were kept in front of local hotels.

In any case, Hardin later claimed that he had "killed five men on the journey and three more at his destination." After killing four black men, he was arrested by the sheriff of Cherokee County. He escaped from jail in October 1872 and was soon back in trouble with the law. Next he killed Deputy Sheriff Charles Webb of Brown County on 26 May 1874. Hardin fled to Florida, and over the next few months killed six more men. With a $4,000 price on his head, he was pursued by numerous bounty hunters. Eventually, he was captured by Captain John Armstrong and a party of Texas Rangers at Pensacola, Florida, on 23 July 1877. He tried to draw his Colt .45 and put up a good fight, but it snagged on his suspenders and the rangers got the drop on him. The following year, he was sentenced to twenty-five years in prison. He was incarcerated at the Huntsville Penitentiary and spent the remainder of his time there studying law, theology and mathematics. Hardin regained his religious faith and became superintendent of the Sunday school in prison.

In 1894, Hardin was released from prison. He joined his children in Gonzales County before moving to Karnes County, where he married Callie Lewis on 8 January 1895. The marriage was not a success, and Hardin moved to El Paso, where he plied his new trade as a lawyer. While in El Paso, Hardin began writing his autobiography.

In 1895, he was back in trouble when he started claiming that he paid Jeff Milton and George Scarborough to kill Martin McRose. Milton and Scarborough were arrested, but Hardin later withdrew his comments and the men were released. His next dispute concerned John Selman. After Selman's son, John Jr., arrested Hardin's girlfriend, Beulah M'Rose, for vagrancy, although some reliable historians report the arrest as having been for "brandishing a pistol in public." Miss M'Rose, in fact, had two .41-caliber Colt six-shooters hidden in her parasol. According to Leon Metz's *John Wesley Hardin*, Miss M'Rose "rose up in her wrath and turned her vocal batteries loose on the officer's head…until the paint scaled off the neighboring woodwork." Hardin began saying unpleasant things about the younger Selman. John Selman Sr. confronted Hardin in the streets of El Paso on the afternoon of 19 August 1895, claiming that Hardin had threatened his son and called him "a cowardly son-of-a-bitch." Shortly before midnight that day, an obviously determined John Selman Sr. stepped through the door of the Acme Saloon with his hand on the butt of his gun and took several determined strides toward the bar. He calmly came up behind John Wesley Hardin, who was playing dice, and shot him in the back of the head, killing him instantly. Selman then fired two more shots into the limp body just to make certain that he had completed the job.[15]

The El Paso police found Hardin's unfinished autobiography in the house he had rented while going through his belongings. The manuscript was

Wagon and mule team, Schreiner Store. *Courtesy of Kerr County Historical Commission Archives.*

Captain Schreiner's Home, Kerrville. *Courtesy of Kerr County Historical Commission Archives.*

handed over to Hardin's children, and the book *Life of John Wesley Hardin as Written by Himself* was published in 1896. Unlike Bill Longley, Hardin probably did commit most of the heinous deeds with which he is credited.

Although John Wesley Hardin's path crisscrossed Kerr County and the surrounding region, it would be his brother who left the greatest mark on local history.

John's brother, James Barnett Gipson Hardin, was the eighth child born to James and Mary Hardin. Actually named "Barnett," he took his father's given name after the elder Hardin's death. Hardin, called "Gip," was born 15 August 1874 in Mount Calm, Hill, Texas. He grew up in Ennis, Texas, and finished school there. After completing his education, he enlisted in the Texas army and was commissioned a first lieutenant. He moved to Junction City and settled at Cedar Creek, about three miles from town, near Joe Clement's place. Gip Hardin taught school in Junction City and lived at the Turman Hotel across from the courthouse during 1897. On 17 January 1898, he married Pearl Turner at Menard, Texas, and moved to a home just three hundred yards away from the Turman Hotel.

One evening, Gip Hardin went to the Turman Hotel for supper. The Turman Hotel was owned and operated by Kimble County deputy sheriff John M.C. Turman and was located at the corner of what is present-day College Street and Fifth Street. After meeting a man named W.A. Taylor, with whom he was not acquainted, he accepted Taylor's offer to join him at his table for supper. The pair seated themselves at a dining table that was already occupied by Tom Morse and Will Haley. Will Haley happened to be the son of a local man who was being tried for murder. At some point during the meal, Gip made some disparaging comments about the elder Mr. Haley. His commentary was apparently laced with foul language, which caused Will Haley to get up and leave the table. Hardin continued to loudly and profanely denounce Mr. Haley, causing Deputy Turman, who had overheard the exchange from the kitchen of the hotel, to come into the dining room and attempt to settle the argument down. Turman asked Hardin and Taylor to leave the hotel. Eventually they complied, stopping in the hallway to claim their hats.

As the pair departed, their coarse exchange continued into the front yard of the hotel. Having heard enough, Deputy Turman announced that he was placing the men under arrest and called on a local man named Trimble to assist him. Turman and Trimble followed Hardin out the door and across the narrow yard to the gate. As Hardin proceeded through the gate, Turman and Trimble grabbed him and pulled him backward in an attempt to place him under arrest. Hardin jerked away from Turman, and immediately the shooting began. There were six shots fired, two by Turman and four by Hardin. Turman was hit in three places in the arm and once through the body, all entering on the right side and exiting through the left. Neither of Turman's two shots hit Hardin.

During the initial trial, witnesses stated that Gip Hardin had fired first, basing this claim in part on their observations of muzzle flashes. The witnesses also surmised that Hardin was the first to shoot since one shot from Hardin's gun struck Turman in the gun hand and finger. The bullet struck in such a way that had Turman fired first, there would have been some evidence of the bullet impact on the butt of his gun. There was not. Hardin, during a later appeal, claimed that he and certain witnesses had not heard Turman place him under arrest and, further, that Turman had fired at him first.

Regardless of which version of this story one finds most palatable, the result is the same: at sunset on the evening of Monday, 28 March 1898, forty-year-old Kimble County deputy sheriff John Turman lay dead at the gates of his own hotel in Junction, Texas. He is buried in Junction Cemetery.

Gip was initially convicted of second-degree murder and sentenced to thirty-five years in prison at Huntsville. After appeal, he was able to arrange for a new trial and a favorable change in venue to Fredericksburg, Texas. That trial resulted in a much lighter sentence. Ultimately, he served only a few years of his sentence.

Grave of Kimble County deputy sheriff John M.C. Turman. *Author's collection.*

After his release from prison, Hardin and his wife, Pearl, lived together for a short time but eventually separated. They had two little girls. Clarice (Tass) was born 6 September 1900 and died in El Paso in 1938. Varda Hardin was born 1 August 1903 and died 6 March 1992 in Huntsville, Alabama. After they separated, Pearl and the girls removed to El Paso and Marfa. Gip left Junction, working for a time at the stockyards in Fort Worth before taking a job transporting horses to Europe for the United States government during World War I. He died in 1918 after reportedly being crushed by two boxcars while working in Florida.

The impact of the Hardin family on the Kerr County area was not inflicted solely by John Wesley and Barnett Gipson. On 18 January 1879, the *Galveston Daily News* reported that among the convicts headed to the penitentiary from San Antonio was William Hardin of Kerr County, who was convicted of theft and sentenced to serve two years. Adding further to this story, it seems that two men robbed Mr. Walker's store in Fort Bend in December. Texas Rangers arrested a man calling himself "Johnson" and held him in camp at Contrary Creek. His real name turned out to be Pickens, a local man, and he became involved with William Hardin when they stole some horses in Guadalupe and Caldwell Counties and subsequently robbed the store in Fort Bend. William Hardin was a cousin of John Wesley Hardin.

The family is one of nature's masterpieces, a private little kingdom all its own. It's a place where minds come into contact with kin. No one who has not been in the interior of a particular family can say for certain what the difficulties of any individual of that family may be. Regardless of their upbringing, no one can predict how the individual members will emerge or how they will meet the world. Isn't it extraordinary that the lives of so many Hardin family members came to meet such violent and lawless ends?[16]

OTHER HARD CASES

A legend is a lie that has attained the dignity of age.

—unknown

JOHN PETERS RINGO
3 MAY 1850–13 JULY 1882

WILLIAM "BILL" WILLIAMS
(ALIAS ANDREW L. "BUCKSHOT" ROBERTS)
CIRCA 1843–5 APRIL 1878

John Peters Ringo, better known to moviegoers as "Johnny" Ringo, was born 3 May 1850.[17] His life story is one of the most popular, yet confusing, legends of the Old West. Ringo gained notoriety in part for his affiliation with the cowboy faction during the era of the "Gunfight at the O.K. Corral" in Tombstone, Arizona. Ike Clanton's group of outlaws was known commonly as "the cow-boys" around Tombstone.[18] Ringo himself was later called "the King of the cow-boys," although not during his lifetime. Aside from verbal confrontations, he took no part in the shootout at the O.K. Corral that involved other members of the gang.

In spite of his fame and notoriety, there are no records of this flamboyant character ever actually being involved in a classic gunfight. Further, his violent death may have come at his own hand. By comparison, some of his companions, like the little-known former Texas Ranger turned outlaw

Scott Cooley, were far better candidates to have the title "gunfighter" bestowed on them.

Ringo was born in Greens Fork, Indiana, and moved to Liberty, Missouri, with his family in 1856. He was a cousin of Cole Younger and contemporary of Frank and Jesse James, who lived nearby in Kearney, Missouri. In 1858, the Ringos moved to Gallatin, Missouri, where they rented property from the father of John W. Sheets. Sheets would later become the "first official victim" of the James Gang when they robbed the Davis County Savings Association in 1869. On 30 July 1864, while the Ringo family was traveling through Wyoming on their way to California, John's father, Martin Ringo, stepped out of his wagon while holding a loaded shotgun. The gun accidentally discharged, sending a load of shot through the right side of his face and exiting the top of his head. Fourteen-year-old John and the rest of his family buried Martin on a hillside alongside the trail.

By the mid-1870s, Ringo had moved from San Jose, California, to central Texas, to the area around Mason County. While there he befriended an ex-Texas Ranger named Scott Cooley, who was the adopted son of a local rancher named Tim Williamson.

For years, relations between the native Texans and German immigrants of the area had been tense. Most Texans supported the Confederacy, while many transplanted Germans were Union loyalists. Trouble started when two rustlers named Elijah and Pete Backus were dragged from the Mason jail and lynched by a predominantly German mob. A full-blown war between the factions began on 13 May 1875 when Tim Williamson was arrested by a hostile posse and murdered by German farmer Peter Bader. Cooley and his friends, including John Ringo, mounted a terror campaign against their rivals in reprisal. This conflict was dubbed the Mason County War (locally known as the "Hoodoo War").

As a well-respected Texas Ranger and Indian fighter, Scott Cooley already had a reputation as a dangerous man. Cooley retaliated by killing local German deputy sheriff John Wohrle on 10 August 1875. He not only shot Wohrle but also scalped him and tossed his body down a well.

Cooley's friend and colleague John Ringo committed his first murder of note on 25 September 1875. Ringo and a friend named Bill Williams rode up to the house of James Cheyney. Cheyney came out of the house unarmed and invited the pair in. As Cheyney began washing his face on the porch, both Ringo and Williams shot and killed him. A short time later, Scott Cooley and John Ringo mistook Charley Bader for his brother, Pete, and killed him. After the Bader murder, both men were apprehended and

jailed in Burnett by Sheriff A.J. Strickland. Soon after, the pair managed to escape custody with aid from a friend. Now free, they parted company to evade the law.

By November 1876, the hostility in Mason County had subsided, but only after having cost a dozen or so lives. Scott Cooley was believed to be dead. John Ringo and his pal, George Gladden, were once again locked up in jail. In an odd twist of fate, one of Ringo's cellmates was the notorious killer John Wesley Hardin. Legend has it that Hardin feared Ringo, citing Ringo's ruthlessness and unpredictable temper as reasons. Like so many such questionable anecdotes that flowed from the pages of pulp fiction novels, there is no way to corroborate this story. Eventually, George Gladden was sentenced to ninety-nine years in prison for the murder of Charley Bader. Ringo was acquitted. He dropped out of sight but two years later surfaced as a constable in Loyal Valley, Texas. Soon after this brief appearance on the right side of the law, Ringo left Texas for Arizona.

Chronologically, Ringo first appeared in Arizona in 1879 around Cochise County with a comrade-in-arms from the Mason County War named Joe Hill. For the most part Ringo kept to himself, only mingling with the local outlaw element when it suited him. In December 1879, a clearly intoxicated Ringo shot an unarmed man named Louis Hancock in a Safford, Arizona saloon. The incident is said to have occurred when Hancock refused a complimentary drink of whiskey from Ringo, stating that he preferred beer. Hancock survived his wound.

In spite of the fact that while in and around Tombstone Ringo kept his mouth shut, people walked in fear of him. He had a reputation for being ill-tempered, but apart from the two unarmed men he had killed (Hancock and Cheyney), there is no evidence of him having been involved in what most would describe as a legitimate gunfight. He may have participated in robberies and killings while in the company of "the cow-boys," and legend credits him with having a high position in the outlaw chain of command—perhaps second only to William "Curly Bill" Brocius.[19] In any case, there is no evidence that Ringo openly confronted any members of Wyatt Earp's faction until 17 January 1882. That incident took place not long after Virgil Earp had been gravely wounded in an assassination attempt.

Ringo and Doc Holliday are claimed to have had a public disagreement during which the pair traded threats that seemed to be leading to a gunfight. Before the confrontation escalated, both men were arrested by Tombstone's new chief of police, James Flynn, and hauled before a judge for carrying weapons in town. Both were fined.

Two months later, on 18 March 1882, Ringo was suspected by the Earps of having taken part in the murder of their brother Morgan. At the beginning of Wyatt's now famous "Vendetta Ride," Ringo was deputized by Sheriff John H. Behan and was among the possemen seeking to apprehend Wyatt and his colleagues.[20] Events did not go the way Wyatt's detractors had planned, and Ringo's best friends were either dead or had been chased out of the country within a few short months.

On 14 July 1882, Johnny Ringo was found dead, laying in the fork of a large tree in West Turkey Creek Valley, Arizona. There was a lone bullet hole in his right temple, with the exit wound at the back of his head. His body had apparently been there overnight. A shot had been heard by a local resident a day earlier, but no one had been observed in the vicinity. Ringo's boots were found tied to the saddle of his horse, which had wandered about two miles from the scene. A coroner's inquest ruled his death a suicide. Nonetheless, many years later, Wyatt Earp's wife attributed the killing to Wyatt and Doc Holliday. She claimed that Wyatt had delivered the fatal shot to the head from a considerable distance with a rifle.[21] Fred Dodge, the Wells Fargo detective and Earp confidant, attributed the killing to Mike O'Rourke, alias Johnny "Behind-the-Deuce." Writer Stuart Nathaniel Lake recorded this version, but some suspect that he did so to cover Earp's role in the affair. Personally, I would prefer to believe that Doc Holliday killed Ringo precisely as the scene was portrayed by Val Kilmer and Michael Biehn in the 1993 movie version of *Tombstone*. Unfortunately, that is unlikely.

John Peters Ringo is buried near the spot where his body was found, on the West Turkey Creek Canyon near the base of the tree.[22]

A man named Bill Williams, who was cited earlier, is said to have been involved with Ringo in the 25 September 1875 killing of James Cheyney in Mason County, Texas. Williams is another example of how the paths of so many of the early outlaws and lawmen crossed and how frequently people turn up in other incidents in vastly distant places.

Bill Williams—like Scott Cooley, Bazel Lamar "Baz" Outlaw, John Selman and others—is an example of a man who stepped back and forth over the line of law and order, having once worn the Texas Ranger star. Williams may have been William "Bill" Williams who served during the Civil War on the side of the Confederacy. He is believed to have been born in Texas, but documentation to that effect has eluded historians thus far. Williams was a Texas Ranger in 1860. It is believed that Indians killed his wife and children on the Sabinal River in 1859 and that he joined the Texas Rangers so that he could participate in tracking them down and killing them. Williams had

been wounded during the war and was again wounded during Indian fights while a ranger. It is possible, although conclusive evidence remains elusive, that after the Mason County War Williams changed his name to Andrew Roberts and left Texas. If that linkage can be proven, then he may be linked to the Lincoln County War as well.

If Andrew "Buckshot" Roberts was Williams, then he got his start on the outlaw trail.[23]

WILLIAM SCOTT COOLEY

Out here a man settles his own problems.
—*Tom Doniphon (John Wayne),* The Man Who Shot Liberty Valance

Circa 1855–June 1876

A complete account of the life and times of Scott Cooley would make a sizeable book on its own. Although gaps in his story exist, his exploits have been recounted numerous times—but only recently with much accuracy. Cooley is another man who left a profound impact on this region of Texas. A brave and skillful lawman and Indian fighter, he was a man driven to the dark side by the murder of his foster father.

William Scott Cooley was born in Texas. When his parents died, he was taken in and raised by a local rancher named Tim Williamson. Folklore has it that Indians killed Cooley's parents in Keechie Valley, Palo Pinto County, Texas. Some have alleged that Cooley was captured by the Indians and held for a short time until local settlers recovered him. This, it turns out, was probably not the case. During the period of 1860 to 1870, Jack County, Texas, was under almost continuous attack by Indians. Scott's father and his two brothers are claimed to have been living on the Picket Ranch in White Prairie and were fierce Indian fighters.

Tim Williamson and his wife nursed Cooley through a serious illness when he contracted typhoid fever as a child. Cooley always treated the couple with the utmost respect. As a young man, he made several cattle

drives with Williamson between 1872 and 1873, and there is evidence of Scott having been in Kansas on 16 October 1873 when he and several other men registered at the Grand Hotel in Ellsworth.

Cooley joined the Texas Rangers while still a youth, on 2 May 1874, enlisting in Company D of the Frontier Battalion. He quickly saw action when, less than two months later, on 12 July 1874, he accompanied other rangers under the command of John B. Jones to Lost Valley, where the group rode into an Indian ambush. On 10 July, Major John B. Jones joined with Captain G.W. Stevens of Company B and moved with them to a camp in Young County. The rangers received word that a band of Comanches had attacked the Loving Ranch and killed cowboys on both 20 May and 10 July. On 12 July, a detachment of about thirty rangers followed an Indian trail for fifteen miles into the Lost Valley, located between Belknap and Jacksboro in Jack County. Unbeknownst to the rangers, they had picked up the trail of a band of fifty Kiowas led by Chief Lone Wolf and his medicine man, Maman-ti. Lone Wolf had been fighting with U.S. troops since 1856. His son and nephew were killed by troops from the Fourth Cavalry on 10 December 1873 in Edwards County.

Some Comanches joined the Kiowas, and the group strength grew to about 150 warriors. The Indians ambushed the rangers, wounding privates Lee Corn, George Moore and William A. "Billy" Glass. A sniping battle ensued, with Glass lying in the open between the two sides. Glass called out, "Don't let them get me. Won't some of you fellows help." Cooley and several other rangers made a dash from cover to bring Glass back to the safety of the gully they had been firing from. Unfortunately, Glass died from his wound.

The other wounded rangers were calling for water, but the nearest stream was a mile away. Private Mel Porter decided to ride to the stream, and Private David W.H. Bailey volunteered to go with him. The rangers could see Bailey seated on his horse covering Porter while he got water. About twenty-five Kiowas moved in on them. Bailey called to Porter to flee. The two rangers took off in different directions, with Porter barely escaping. Private Bailey was cut off, surrounded and levered off his horse with a lance. Lone Wolf himself chopped Bailey's head to pieces with a brass hatchet-pipe and then disemboweled him. Satisfied with revenging his son's and nephew's deaths, Lone Wolf ordered his band to depart. At 3:00 a.m. the following day, the rangers and army troopers returned and recovered Bailey's horribly mutilated body.

After evading federal troops and conducting several more raids, Lone Wolf surrendered to the U.S. Army at Fort Sill, Oklahoma, on 26 February 1875. He died soon after his release from prison in 1879.

Scott Cooley was well respected as a lawman and, many claim, feared due to his record of relentless pursuit Indians and lawbreakers. He left the ranger service on 4 December 1874. On 13 May 1875, Tim Williamson was falsely arrested in Mason County for cattle rustling by Deputy Sheriff John Wohrle.[24] While Wohrle was escorting Williamson to jail, a mob of angry German cattle ranchers jerked Williamson aside and shot him to death. This event marked the beginning of what would be called the Mason County War, also known as the "Hoodoo War."

When Cooley received the news of his foster father's murder, he swore revenge. Some accounts of this event claim that Cooley was at the ranger camp visiting friends when he received the news of Williamson's assassination and that he began crying uncontrollably. His sorrow, however, quickly turned to anger. Cooley blamed Wohrle for Williamson's death, believing that he was acting in fellowship with the German faction. Wohrle was of German descent.

Cooley patiently waited for indictments to be passed down from the court against those responsible for Williamson's death. When none came, he took matters into his own hands. Cooley went to Wohrle's home and found him working on his well with a helper. He shot and killed Wohrle on sight. Next he scalped him and afterward displayed the trophy to the Germans. Before leaving, he tossed Wohrle's body down the well.

Soon after the Wohrle incident, Cooley killed German cattleman Carl Bader. By that time, gunman John Ringo and several other supporters had joined with Cooley in the fight. Following the Bader slaying, two of Ringo's friends, Moses Baird and George Gladden, were ambushed by a posse led by Sheriff John Clark. During the ambush, Baird was killed and Gladden seriously wounded. That posse included Peter Bader, brother to Cooley's second victim, Carl Bader.

On 25 September 1875, John Ringo and William "Bill" Williams rode boldly into Mason County and headed for the home of James Cheyney, the man who led Gladden and Baird into the ambush. As Cheyney came out of the house, Ringo and Williams shot and killed him. Afterward, the pair rode to the house of Dave Doole and called him out. When Doole appeared in the doorway with a gun, they fled back to town. Four days later, Scott Cooley and John Baird, brother to Moses Baird, killed German cowboy Daniel Hoerster and wounded Peter Jordan and Henry Plueneke.

The German cattlemen retaliated, hanging two men they suspected of having assisted Cooley. The next day, Texas Rangers arrived, finding the town in chaos and Cooley and his faction gone. Ranger major John B. Jones dispatched three parties to pursue Cooley and his followers. The

following day, local sheriff John Clark sent a posse of deputies to arrest Bill Coke, who was suspected of assisting Cooley. Coke was located and arrested but allegedly "escaped" while on the way to town. Coke was never seen again. Most believe that the posse executed him. Soon after the Coke disappearance, Charley Johnson, a friend to Bill Coke, appeared in town looking for a blacksmith named William Miller. Miller had been a member of the posse that had assassinated Coke. He found Miller at his workplace and shot him. Badly wounded, Miller was saved by his wife, who ran outside and threw herself toward him. Johnson simply walked away.

By this time, the killings in Mason County were almost random. With the sheriff a known supporter of the German faction, there was no local law enforcement to speak of. No one on either side of the struggle had been arrested, except for the unfortunate Bill Coke. The Texas Rangers were doing little to help matters. Many were friends of Scott Cooley and did not have their heart in the fight. Frustrated, Major Jones asked that all who felt they could not perform their duty by pursuing Cooley step forward. Seven rangers boldly did so, willing to accept discharges rather than pursue a man they respected and admired.

By this time, the Texas governor's office was receiving letters in support of Cooley and stating that the local sheriff was acting in support of the German cattlemen. This information was filtering down to Major Jones, prompting him to act swiftly.

At the end of December 1875, Sheriff A.J. Strickland arrested Cooley and Ringo for threatening the life of Burnett County deputy sheriff John J. Strickland. The pair later escaped from the Lampasas County jail, with the help of friends. Their arrests essentially stopped the violence. Cooley later escaped a posse near the Llano River, fleeing into Blanco County. Reports persisted that Cooley had been wounded by that posse and died shortly thereafter, but he escaped the posse unharmed and hid out at the Nimitz Hotel in Fredericksburg.

After eating supper at the Nimitz one afternoon, Cooley felt sick and returned to his room. He died a short time afterward, presumably of what was then referred to as "brain fever"—a term used to describe what is now more accurately called meningitis, or encephalitis. It is an infectious disease characterized by inflammation of the meninges (the tissues that surround the brain or spinal cord), usually caused by a bacterial infection. The symptoms include headache, stiff neck, fever and nausea. All of these symptoms would have fit those claimed to have been experienced by Scott Cooley as witnesses later described them.

Cooley is buried at Miller Creek Cemetery near Blanco, in Blanco County. The cemetery is located east of Highway 281 off Highway 290. His tombstone is inscribed simply, "Scott Cooley 1852–1876." Perhaps someday local concerned historians will correct the information. It should read, "William Scott Cooley 1855–June 1876."

JOHN D. NELSON

Duty is the most sublime word in our language. Do your duty in all things. You cannot do more. You should never wish to do less.

—Robert E. Lee

Deputy Sheriff, Kerr County, Texas
1842–12 November 1882

Early on a Sunday morning in November 1882, while local citizens were hustling about performing their morning chores and preparing for church services, Kerr County deputy sheriff John D. Nelson stood near a street corner in downtown Kerrville visiting with passersby. To Deputy Sheriff Nelson, it probably seemed like any other ordinary fall morning as he observed the sun rising to the east down Water Street, not suspecting that this day would be his last. Deputy Nelson would be dead before noon, shot down on that peaceful street corner at about 6:00 a.m. by his assassin, Tom Baker.

John Nelson was born in Texas, but diligent research has yet to reveal precisely where. The 1850 census shows him, his widowed mother Elizabeth and siblings Jane, Lorenzo and Rowland living with the Jonas Harrison family at Cibolo, in Bexar County. At the time of the 1850 census, his younger brother, Lorenzo, was yet to reach his first birthday, giving rise to the belief that John's mother had been recently widowed. By the 1860 census, John had moved to Kerr County and was living with the family of Sayne Nichols. The remainder of John's family, including his mother, sister

and two brothers, seem to have disappeared from history entirely sometime between 1850 and 1860.

Nelson served for the Confederacy during the Civil War, as a private in Jones's Texas Light Artillery. After discharge he returned to Texas. He enlisted in Company F of the Frontier Battalion of the Texas Rangers on 4 June 1874 and served under Captain Neal Coldwell. Nelson requested a transfer to Captain McNelly's Company A of the Frontier Battalion, probably so that he could return to the Kerr County area, where he had lived before the Civil War. The service records of both Company A and Company F of the Frontier Battalion of Texas Rangers for the period during which John Nelson served are too lengthy to recount here, and they are so filled with valor and individual bravery that they read like an award citation rather than an account of history.

Throughout the 1870s, outlaws plagued Kerr County. In July 1873, a gang of seventeen bandits attempted to rob the Valentine and Schreiner Store in Kerrville. After receiving word of the impending attack, the owners killed five of the outlaws in a shootout on Water Street. Twelve escaped. A posse of eight men caught up with these outlaws about ten miles from Kerrville. In August 1873, another gang was captured near Buffalo Branch, a stream leading into the south fork of the Guadalupe River. The area that had to be

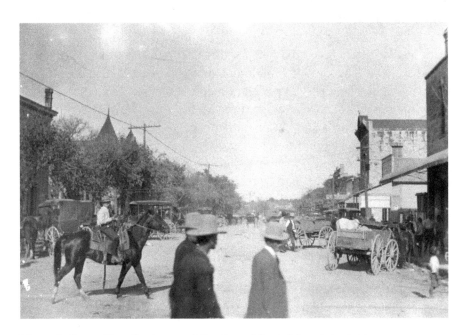

Mountain Street, Kerrville. *Courtesy of Kerr County Historical Commission Archives.*

Schreiner's Store, Kerrville. *Courtesy of Kerr County Historical Commission Archives.*

covered by Company A at the time was enormous by any standard, and the continued Indian menace caused a home guard unit, called the Kerrville Mounted Rifles, to be organized in 1875. Charles Schreiner was elected captain, a title he carried the rest of his life.

It is likely, although yet unconfirmed, that John D. Nelson was related to H. Louis Nelson, who established the first post office at Mountain Home, Texas, in 1879. The town of Mountain Home was first settled in about 1856 by storekeeper Thomas A. Dowdy as a supply center for area ranches.

Nelson served as a Texas Ranger until March 1876, when he returned to the Kerr County area and became a deputy sheriff for the county. At the time of his death, Nelson was forty years old, an experienced and seasoned veteran. Reports of the day claimed that bad blood existed between Nelson and a local man named Tom Baker. On the night of Saturday, 11 November 1882, Nelson and Baker had "differences" that escalated to a point where they had to be separated by bystanders. At about six o'clock the following morning, Tom Baker armed himself with a Winchester rifle and approached Deputy Nelson in front of the Schreiner Store at the corner of Water Street and Mountain Street. He walked up to within twenty paces of Nelson before the deputy saw him coming. Baker fired a shot at Nelson that passed diagonally through his lungs. Nelson fell to the ground. As Baker advanced, he fired again, this time breaking Nelson's left arm. Baker was about to

fire a third time when Nelson is reported by witnesses to have exclaimed, "You have killed me, don't shoot any more." Deputy John Nelson died of the wounds received in this cowardly ambush at about 10:15 a.m. on 12 November 1882.

After the shooting, Baker immediately fled the scene. Sheriff Buck Hamilton of Bandera County was in town on business and, although out of his jurisdiction, immediately gave chase. He soon came upon Baker at the edge of town. Hamilton fired three shots at long range, missing Baker. Baker's father, after hearing what had happened, had also given chase. He caught up with his son, dismounting, and gave him his horse so that he could make good his flight.

Thomas Baker was born in about 1861, probably in Texas. His father, William Alfred Baker (born 1824), and mother, Sarah, had come to Texas from Alabama. Baker was eventually arrested, imprisoned and stood trial for the murder of Nelson. The 12 June 1886 issue of the *Galveston Daily News* reported that "Tom Baker's appeal to the Texas Supreme Court was reversed and he was remanded into custody." Not long after, on 14 July 1886, he lost the appeal that he had filed. The *San Antonio Daily Express* reported that "Tom Baker arrived in San Antonio with prison contractor McCulloch from Kerrville to serve his twenty five year sentence for the murder of Deputy Sheriff John D. Nelson." After Baker's incarceration, he seems to have disappeared from history.

Nelson was not married. Although no record of his interment can be located, in all likelihood he was buried in an unmarked grave at one of several local cemeteries. Likely his remains are at Sunset Cemetery, which is located about seventeen miles west of Kerrville. H.L. Nelson and family, believed to be related to Deputy Nelson, are buried there.

It seems unfair that a man's life can be snuffed out instantly by a coward's ambush. Orphaned during his early childhood, having served bravely in the Civil War and later valiantly serving as a Texas Ranger and ultimately as a deputy sheriff, John D. Nelson's untimely death seems another mistake of destiny.[25]

DAVY THOMAS CARSON

There were all kinds of things I was afraid of at first, ranging from grizzly bears to "mean" horses and gun-fighters; but by acting as if I was not afraid I gradually ceased to be afraid.

—Theodore Roosevelt

Texas Ranger
22 December 1852–21 April 1893

L ike so many other remarkable men who left an indelible mark on the Texas frontier, the sparse records and frequent gaps leave us with an incomplete story of Davy Tom Carson. Yet-to-be-found records, perhaps to be discovered by the next diligent historian or ardent amateur, may yield additional knowledge. Nonetheless, what we know of Tom Carson's life thus far makes for a fascinating tale.

The Texas State Archives show several men named Carson who served proudly in the ranks of the Texas Rangers. D.T. Carson, or Tom Carson as he was often called, is not the Thomas F. Carson who was with the Texas Volunteer Guard in 1897. He is also a different Tom Carson than the one who was part of the Texas State Police in 1873. He is, as far as can be ascertained, not related to any of the other half-dozen men named Carson who also served.

Historians have often confused, merged or combined the paths of notable characters who appear to have similar or identical names. One such notable case is that of Thomas Carson, said to be the nephew of famed mountain

man Christopher Houston "Kit" Carson, who went to work for "Wild Bill" Hickok in Abilene, Kansas, on 14 June 1871. Thomas Carson is reported to have roughed up the noted outlaw John Wesley Hardin when Hardin was apprehended for carrying a firearm in Abilene. Carson later relocated himself to Newton, Kansas, where he was a constable or deputy sheriff. By November 1871, he was back in Abilene, working under Sheriff John W. "Brocky Jack" Norton. Later that same month, in Abilene, Carson shot a bartender named John Man in the hip, injuring him seriously but not mortally. Both Carson and Norton were discharged of their duties as lawmen on 27 November. In a strange twist of events, Carson later shot Norton, albeit not fatally. Carson was imprisoned but escaped on 18 February 1873. By most accounts, he met his end several years later in Kansas. Although some historians frequently merge the paths of these two Tom Carsons, this "also famous" Carson is quite certainly not the same Tom Carson on whom we are presently focused.

From various records, we can conclude that Tom was born Davy Thomas Carson on 22 December 1852 in Hendricks County, Indiana. He was the son of Davy and Marsolete (Gill) Carson. He had one brother (Walker B.) and three sisters (Tennessee, Savinia and Cassa). Carson married Georgann Weaver in 1876. Georgann was born in 1856 as well, at the town of Woodville, in Tyler County, Texas. She died in 1882. Not long after their marriage, Carson pledged his first oath to the Texas Rangers, with whom, according to archived records, he remained from 1 September 1878 through at least 31 August 1882. When Georgann passed in 1882, that event may have signaled a new direction or pursuit for Tom, thus his departure from ranger service.

While serving as a ranger, he used the name D.T. Carson, Thomas Carson or Tom Carson interchangeably. It seems he never used his given name of Davy Thomas Carson, favoring the initials D.T. His unit, Company D of the Frontier Battalion, was at the time of his enlistment camped on the San Saba River about twenty miles south of Fort McKavett. The company had experienced numerous Indian fights in earlier years. The life of a Texas Ranger in those days was not at all an easy one. Life in Texas, in general, was an arduous one for all but the prosperous. It has often been said that Texas, in the early years, was "heaven for men and dogs and hell for women and oxen." All that the state furnished the rangers for shelter were canvas tents, which worked well in warm months but proved quite inadequate during the often bitter winter weather. Generally, log huts, dugouts or cabins were constructed—predicated, of course, on how much timber was available.

Company D constructed its log shelters along the San Saba while in winter quarters in 1878. Typically, a group of five or six men would build

a hut about sixteen to eighteen feet square, with a fireplace and chimney centrally located. Rangers also took advantage of any abandoned buildings or ruins available, constructing makeshift shelters as a barricade against the penetrating cold of the frequently severe Texas winters. To those readers who make their homes in the northern reaches of this great United States, or beyond in Canada, it may seem odd to refer to Texas winters as being brutally cold. It is a matter of perspective and relativity. First, when one has become accustomed to ninety-five-degree days and seventy-degree nights for practically eight months of a year, a blustery winter day in the twenties with a stout Blue Norther[26] cutting through your coat and trousers as if they were made of limp burlap feels just as cold as being left on an ice floe completely naked in the Bering Sea.

By the year 1878, the frontier of Texas had pushed its way into the far western portion of the state. After Charles Goodnight established his ranch in the Palo Duro in 1876, other cattlemen crowded into the Panhandle to take advantage of the free range land. Immediately behind the cattlemen were the farmers, the nesters, and the railroads with their unruly camps and unsavory camp followers. Cattle thieves were in evidence all around, and in response the state found it necessary to station companies of rangers farther west than they had been before. The frontier had moved from the Nueces River to as far as the El Paso section of the Rio Grande. It now included a portion of central Texas following the cattle drives to the Palo Duro Canyon area and beyond to the farthest corners of the Panhandle. Texas was now a fairly safe place to live.

Tom Carson and the Frontier Battalion Company D had fought their way across Texas, with action in the Mason County War, the Salt War and the Horrell War. At the end of the open hostilities of the Lincoln County War in New Mexico in July 1878, members of both factions split up and headed in different directions. Members of both, however, eventually wound up in Texas. Noted cattle thief, outlaw and killer Jessie Evans was released from jail in New Mexico on 19 March 1879. Evans, who by some accounts claimed to have been born in Morgan County, Alabama, in 1853, had come to New Mexico from Texas (although in 1878 Evans himself is said to have claimed Texas as his place of birth). Others believe that Jessie Evans was born in 1850, in Kalona, Washington County, Iowa, to father Jessie Evans Sr. and mother Louisa E. Looney.

A man of average proportions at about five feet, six inches, Evans tipped the scale at about 150 pounds. He had determined gray eyes, light-colored hair and fair complexion. There was, however, nothing average about this desperado. Accompanied by a small band of his loyal followers, mostly

former members of the Seven Rivers Gang, the group made its way to southwest Texas and settled in the Fort Davis/Marfa/Alpine vicinity. Evans and his colleague, John Selman, had set up a rather efficient and profitable cattle butchering operation at Fort Davis, made all the more profitable by the fact that the cattle they were processing had been stolen from local ranchers. Evans's gang terrorized the area for some time, until May 1880, when the Presidio County attorney had had enough and sent a dispatch to Governor Roberts requesting his help. This plea went unanswered.

In June, Pecos County judge G.M. Frazer telegraphed Major Jones of the Ranger Frontier Battalion and once again made a plea for help. Under forced march, members of Company D of the Frontier Battalion under the command of Sergeant Edward A. Sieker arrived at Fort Stockton on 6 June 1880. The group consisted of but eight rangers: George R. "Red" Bingham, Nick K. Brown, D.T. "Tom" Carson, Samuel A. "Sam" Henry, J.W. Miller, E.J. Pount, R.R. "Dick" Russell and Henry Thomas—all privates. Major Jones had also ordered Lieutenant C.L. Nevill of Company E to send a detachment of rangers to Fort Stockton under the command of Sergeant L.B. Caruthers. For practically three weeks the rangers looked for leads as to the whereabouts of Evans and his crew, with little success. Finally, a black informant named Louis told the rangers where the Evans gang was hiding out. He had discovered them in the Chinati Mountains southwest of Fort Davis.

Major John B. Jones ordered Sergeant Sieker to take several men and one Mexican guide and head out from Fort Davis toward Presidio in search of the outlaws. On 1 July 1880, Sieker, along with Samuel A. Henry, Tom Carson, R.R. "Dick" Russell, L.B. Caruthers, George "Red" Bingham and the Mexican guide, rode out of Fort Davis after nightfall heading southwest through the wide-open and desolate country lying between the fort and Marfa and then beyond through the broken hills strung out along the base of the Chinati Mountains. Their dark pathway was bathed only in the dim light of a crescent moon, leading them out of the Davis Mountains and past Blue Mountain to the west and then onto the expanse of open country that stretched for miles. Ed Sieker was an experienced hand and able ranger, having been in the service since May 1874. Sieker knew that traveling largely by night would be easier on men and horses and would enable them to cover more ground during the less punishing temperatures of the brutal summer months, when it's not unusual for the mercury to break one hundred degrees during the day.

After traveling over roughly eighty miles of parched, largely treeless countryside southwesterly to a point about eighteen miles north of Presidio,

along Cibolo Creek near present-day Shafter, Texas, they caught up with Evans's band on 4 July 1880. Evans and his company of outlaws spotted the rangers and fled, firing at the rangers as they went riding full out through the broken terrain. The chase lasted about two miles, with the outlaws reaching a point where the mountain had a flat top with a sheer rock ledge on the opposite side, making it impossible for them to continue further. Their escape route now blocked, they dismounted and took up positions to fight it out with the rangers. The terrain did not afford the rangers an opportunity for a flanking move, nor did it provide them with much cover from the gunfire being laid down by Evans's men. Two rounds struck Tom Carson's horse, and his hat was practically shot off when another round pierced the brim. In a desperate charge across open ground, Ranger Carson caught George Graham in the side with a shot from his carbine, taking him to the ground. Wounded but unwilling to quit the fray, Graham rose up to continue firing at the ranger. Sergeant Sieker quickly fired on Graham, with the shot striking him in the head and killing him instantly. Next, Ranger Bingham was shot and killed. Bingham's colleagues did not see the shooting take place, nor did they observe Jessie Evans fire the killing shot as the wounded Bingham desperately tried to lever another round into his now jammed Winchester carbine. Had they seen this, Sieker would later say, "I should have killed them all."

Here is an account of the events of 4 July 1880, albeit leaning somewhat more in favor of Tom Carson, as follows:

> *A force of Texas Rangers arrived in Fort Davis on 6 June 1880 and immediately set about tracking down Jessie Evans. On 4 July 1880 Evans was soon located in the Chinati Mountains, about eighteen miles north of Presidio, Texas, along Cibolo Creek where Texas Ranger Sergeant L.B. Caruthers and his men cornered the gang in a running gunfight that covered about a mile in distance. During the fight Evans shot and killed Texas Ranger George Bingham, shooting him down in cold blood when Bingham's Winchester had jammed during the shootout. Evans was captured, the fight ended and the remaining outlaws ran off soon after Ranger Tom Carson shot outlaw George Gross directly between the eyes killing him quite dead.*

It's difficult to tell which account is most accurate at this late date.

Bingham, reportedly born in Missouri, was about twenty-eight years old at the time of his death. After burying George "Red" Bingham, the rangers tied up their prisoners and took the Evans gang back to Fort Davis, where they were placed in the jail. The jail at Fort Davis was of the Mexican

design and was, in fact, little more than a dungeon, being a square adobe structure with the rooms in the center and the doors opening outward into a courtyard. The jail was a dismal place with little or no light penetrating the jail room itself.

It had taken the Texas Rangers only four weeks to bring the reign of lawlessness of Jessie Evans to a close. Evans was subsequently convicted of robbery and manslaughter in connection with the killing of George Bingham and sentenced to a total of twenty years in prison. Evans, prisoner no. 9078, served about a year and a half of that sentence at the state prison in Huntsville, Texas. He escaped in 1882 and disappeared from history entirely. Some have concluded that he returned to his outlaw ways and was killed shortly after his escape. Others postulate that he went straight and lived out his years somewhere in Texas. In 1927, Texas Ranger captain James B. Gillett, who was living in Fort Davis at the time, was trying to correct some of the report errors that had occurred over time. Gillett's report claims that Evans had been killed while attempting to escape from the Huntsville prison. It is unlikely that we will ever be certain of his fate. Given that he was a criminal, virtually from birth, this author has always believed that he was either killed during or shortly after the escape—else he would surely have surfaced again in connection with some nefarious deed.

Tom Carson concluded his regular service as a Texas Ranger in 1882, the same year that his wife Georgann passed away. His trail goes cold for a short time, and despite diligent research to uncover it, there is little clue of his whereabouts until the point when he arrived at nearby Junction City, Texas, sometime in 1883. The town had originally been named Denman after its first surveyor, became Junction City in 1877 and simply Junction in 1894.

Tom went into partnership with Andrew Jackson "A.J." Royal—who owned the Royal House Saloon in Junction City—born in Lee County, Alabama, on 25 November 1855. He married Naomi Obedience Christmas on 19 January 1879 at Junction City, Mason County. Naomi was born at Coryell County, Texas, on 13 November 1863, and she lived until 1 September 1950, dying at San Angelo, Tom Green County, Texas.

The saloon Carson and Royal operated had originally been called the Star Saloon and was operated by William Homer "Bill" Franks. It was the first such establishment in Junction City. Records indicate that A.J. Royal operated the Royal House Saloon as early as 1894, such record being mentioned in a survey of local businesses that was done on 15 March 1894. Carson and Royal's saloon was located on the site later occupied by the Schreiner-Hodges warehouse at the corner of what is now Sixth and Main

Above: Site of Royal House Saloon, Junction, Texas. *Author's collection.*

Left: Whiskey bottle from Tom Carson's Saloon, Junction City, Texas. *From the Greer Kothmann Collection. Image from author's collection.*

Street. The old stone-fronted edifice has housed many businesses over the years but is today the home of the local U.S. Department of Agriculture office in Junction. The previous owner, William Homer Franks, was in New York on 7 September 1850 and by 1880 was operating a saloon in nearby Maverick County. After his first wife died, he came to the Junction area and married Sarah Josephine Wilson on 14 February 1882.

On a bitterly cold night in the winter of 1884, Carson and Royal were locking up the saloon at closing time. Jim Stout, with whom they had been playing cards, was with them. For some reason, Carson suspected Stout of being in the process of pulling his pistol on him. Tom beat Stout to the draw, shooting him on the spot. Stout succumbed to his wound, dying later that evening. Both Carson and Royal were indicted for the murder. At the trial, a man named N.C. Paterson testified that while he was giving aid to Stout after the shooting, Stout said that he "went to that saloon tonight on their invitation to have a little game. I thought Tom Carson was the best friend I had…boy, don't ever put too much confidence in a man—not even a friend." In spite of the testimony, the jury found Carson and Royal to be not guilty.

On 23 March 1888, there is record of Tom Carson being involved with Sheriff P.C. Baird and Deputy J.C. Butler of Mason County in the capture of a local miscreant. The *San Antonio Daily Express* reported:

> *Junction City—23 March 1888—Sheriff P.C. Baird and Deputy J.C. Butler of Mason County assisted by Tom Carson and Bud Fleming of Kimble arrested at the mouth of the Big Point, in this County, after a trail from Mason to Edwards, thence to Kimble County, G.W. Thomason, wanted in Mason County on the following charges: Three counts of assault with intent to murder and of assault with intent to rape. The prisoner, it is understood, notified the Sheriff of Mason that he would not be taken unless he was good and ready, but this kind of talk did not go when such officers as the above are on the trail. The prisoner is lodged in jail here and will be taken to Mason tomorrow.*

One can imagine that Tom Carson traveled to San Antonio from Junction on occasion, and there is at least one record of him having done so. The *San Antonio Daily Express* newspaper of 1 February 1888 reported that Tom Carson of Junction City arrived at a hotel in the city. Covering the distance from Junction to San Antonio is a long ride on horseback, with the town of Kerrville lying midway between the two points. Kerrville was a frequent stopping point and was an often visited place, it being along the path of the

cattle drives from the Rio Grande Valley north. In the spring of 1893, Tom Carson made a fateful journey to Kerrville that would turn out to be his last.

Among the many saloons and watering spots operating in Kerrville at the time was the establishment of Benton-Weston. Locals Mack F. Weston (1872–1961) and William Counts Benton (1871–1922) operated the Benton-Weston Saloon, often referred to as the Weston Saloon. This was truly a rowdy establishment, with a sporting house located on the second floor. The establishment was also operated under the name of the Barlemann Saloon and the Cowboy Saloon at various times during its long history. The original site of the Benton-Weston is 201 Mountain Street. The building is still standing and is currently the site of Francisco's Restaurant.[27]

On the night of 21 April 1893, the fifty-seventh anniversary of the famous Battle of San Jacinto, Carson was involved in an altercation with a man named Bill Holman (or Holliman) at the Benton-Weston Saloon. The episode turned ugly, and Bill Holman shot and killed Carson for reasons still unknown. The body of Tom Carson was returned to his home in Junction City. Definitive evidence as to the location of his burial site continues to elude researchers. There are at least eleven cemeteries and individual burial places in Kimble County that contain nearly fifty unmarked or unidentified graves, thus it is likely that Tom Carson's final resting place will continue to be a mystery. Locals believe that his remains lie in one of the unmarked graves in the Copperas Cemetery.

Bill Holman was tried the following year for Carson's murder but was acquitted. Holman himself was not long for this world. Judge James Cornell shot and killed him at Del Rio, Texas, not long after the Carson incident. Cornell was subsequently acquitted of Holman's murder.

Carson's partner, A.J. Royal—reportedly concerned about legal matters surrounding the shooting he was involved in with Carson back in the winter of 1884—pulled up stakes and moved to Fort Stockton, Pecos County, Texas. He arrived in 1889 in the all-but-abandoned town that had been bypassed by the railroad and deserted by the army. Royal bought 265 head of cattle and a 1,800-acre ranch with irrigated land located seven miles west of town. He also set up a saloon business and bought the former post trader's building in town. Royal ran for commissioner in 1890 and won, winning a subsequent election to the post of sheriff of Pecos County on 8 November 1892.

Royal's years in Fort Stockton passed, but not without incident and high drama. A dangerous bully when drinking, he was repeatedly accused of brutally beating, and often shooting, troublemakers. In February 1894, while still county sheriff, he decided to go back into the saloon business. Although

Former location of the back door of the Royal House Saloon, Junction, Texas. *Author's collection.*

Royal and Texas Ranger J.W. Fulgham were involved in the arrest of federal fugitive Victor Ochoa, he was later suspected in aiding Ochoa in his escape. Royal lost his bid for reelection to the post as sheriff to R.B. Neighbors and, although not the sheriff at the time, was gunned down from ambush while seated at the sheriff's desk in Fort Stockton at about four o'clock in the afternoon of Wednesday, 21 November 1894. A.J. Royal was thirty-nine when a blast from a shotgun cut him down. The identity of Royal's killer remains a mystery, although one popular line of speculation is that a Texas Ranger did the deed. This supposition would gain further support as recently as 1970 when local historian Lee Harris interviewed a former Texas Ranger, then in his nineties, about the incident. The old ranger's simple answer, "Why do you ask?" may be all we need to know.

Of the group of six rangers who set out on 1 July 1880 to capture Jessie Evans's gang (Edward A. Sieker, Sam Henry, Tom Carson, R.R. Russell, L.B. Caruthers and George "Red" Bingham), all but Red Bingham seemed to have survived their ranger service—and all those remaining except Carson and Russell lived to collect a well-deserved pension for their service.[28]

THALIS TUCKER COOK

Texas Ranger
10 March 1858–2 July 1918

I freely admit that traveling the distance from Mountain Home to Uvalde in a day's ride would require the rider to rack out at a gallop at dawn in the early hours of a midsummer's day, mounted on a strong horse, in order to arrive before sunset and only after having traveled across roughly sixty miles of broken ground—not a feat one would wish to perform often. Nonetheless, the story of T.T. Cook is one that needs to be told in spite of the fact that his home in Uvalde is on the fringes of a day's ride.

Though surpassed in fame by many of his peers in nineteenth-century Texas Ranger lore, few if any can best Thalis Cook when it comes to courage and toughness. Thalis Tucker Cook was born on 10 March 1858 in Uvalde County, Texas. His parents, David and Eliza Jane, were among the earliest settlers in the area. It seems that adventure was a family trait. One of his cousins was Tom Folliard, who rode with Billy the Kid, played a key role in the Lincoln County War of 1878 and was also killed by Pat Garrett.[29]

The sixteen-year-old Thalis was undoubtedly one of the youngest rangers to have ever served in the Frontier Battalion when he dropped his Bible study and joined Captain Neal Coldwell's Company F on 4 June 1874. He later served in Company D. As was customary for Texas Rangers before the birth of the Department of Public Safety in 1935, Cook would be in and out of ranger service many times over the next several decades. Thalis was a

crack shot and killed without compunction. But his virulent tendencies were somewhat tempered by the fact that he was an avid Bible student and active church worker. Cook is sometimes mentioned with Captain John H. Rogers and Augie Old as the "Christian Rangers." When not rangering, Cook spent most of his time in the ranching business or serving as a deputy sheriff. Although he was involved in many gunfights and affrays over the years, a few stand out and have been written about on occasion, although Cook's deeds have escaped the notoriety afforded lesser men.

One of Cook's significant performances as a ranger occurred on 31 January 1891. Cook and fellow ranger J.M. Putman were trailing an outlaw named Fine Gilliland who was wanted for the murder of rancher H.H. Poe. By some accounts, Cook was a Brewster County deputy sheriff at the time and not on active duty as a Texas Ranger. In any case, the pair finally caught up with Gilliland in the Glass Mountains northwest of Marathon near the Big Bend Country. Passing through a narrow canyon, Cook and Putman met another rider. The lone rider pulled over to the left to let the rangers pass. Cook immediately became suspicious of this maneuver, as it was customary for riders to move off the trail to the right. Moving to the left was a favorite trick of outlaws and gunmen. (By being on the left, the rider's gun hand was closest to the rangers, thus allowing him to shoot without having to turn in his saddle.) Nearing Gilliland, Cook saw that he was attempting to conceal his drawn pistol under his coat, which was thrown across the saddle horn. Just as Cook turned his horse to identify himself, Gilliland opened fire.

Gilliland's first shot hit Cook in the right kneecap. The impact blew Cook out of the saddle. Gilliland put the spurs to his horse in an attempt to escape. Cook yelled out to Putman to shoot the fleeing outlaw's horse, which Putman did. Hitting the ground, Gilliland crawled behind his dead horse's body, using it as a shield as he continued firing at the pair of lawmen. In the ensuing gunfire, Gilliland put a bullet into Putman's horse. The three men continued to fire away at one another until the return fire from Gilliland's position ceased. Ranger Jim Putnam waited, kneeling on the icy ground as he took careful aim with his Winchester. When Gilliland popped his head up to fire again, Putman squeezed off a shot from his Winchester, and Gilliland dropped back behind his dead horse. After a few minutes of painful silence, Cook called out for Putman to cover him as he was going to rush Gilliland's position. Using his rifle as a crutch, Cook hobbled over to where Gilliland was forted up behind his dead horse. There he discovered the outlaw's limp corpse with a .45 slug squarely between his eyes.

Cook's ordeal was just beginning, however. His kneecap was shattered, and he needed a doctor quickly. The closest doctor was fifteen miles away at Marathon. Cook and Putman had but one horse and a pack mule between them. Putman's horse had been injured in the gunfight and had to be put down, and Gilliland's horse was quite dead. Mounting the pack mule, Cook somehow managed to survive the grueling ride back to Marathon. The doctor repaired his leg as best he could but told Cook that his leg would be stiff and not much use to him from then on. But a stiff leg wasn't going to keep Cook from his job. When his leg finally healed, he found it not only stiff but also locked in a straight position, making it extremely difficult for him to ride a horse. There was only one thing for him to do. He ordered a doctor to break his knee again and reset it in a slightly bent position so that he could sit on a horse properly. He would walk with a limp from that point forward, but he could still ride!

On 28 September 1896, Cook was a member of a posse led by John Hughes that had tracked a trio of cattle rustlers to Nogalitos Pass. The threesome of outlaws consisted of Art and Jubel Friar and Ease Bixler, whom the rangers soon trapped on a mountaintop near the pass. As the rangers closed the distance, the outlaws opened fire, raining lead down on the small posse. Circumstances would quickly turn for the outlaws, however. When Jubel Friar rose up from his shelter to fire, Ranger Thalis Cook shot him through the head with his Winchester. His brother Art Friar had already been hit twice and yelled out, "I have got enough." Cook ordered him to raise his hands and come out—"Hands up then...manos arriba," he shouted. Cook and Hughes advanced on Art Friar to disarm and arrest him, but as they approached Art began to fire on them with his pistol. Both Cook and Hughes fired practically simultaneously. Both bullets found their mark, cutting down Art Friar in his tracks. Meanwhile, Ease Bixler had managed to mount up and ride off to safety.

A fellow named Bud Newman first came to the attention of the Texas press late in 1895 when the *Dallas Morning News* reported that on 1 December a "difficulty" between Newman and Shepard Baker ended "after several shots were fired." Newman went to jail; Baker went to the cemetery. Others said that the two cowboys had shot it out near Kelly's Saloon by the Comstock bone yard and were said to have been feuding over some matter long since forgotten. The day of the shooting, Baker happened to be sitting in a wagon when he spotted Newman and promptly took a shot at him. The sound of the gunfire spooked the team pulling the wagon, and Baker could not get off a second shot. Newman rested his Winchester on the saddle of his

borrowed horse, took careful aim and put a round right between Baker's eyes. Newman eventually gained release from jail in Del Rio on $3,000 bond and was acquitted of the killing of Baker on grounds of self-defense.

A little more than a year after the Baker shooting, the westbound Southern Pacific passenger train no. 20 was robbed about midnight on 20 December 1896 near Cow Creek, less than a mile west of Comstock. Three men, including Bud Newman, had boarded the train with pistols blazing and tied up the train crew, taking seventy dollars from the small strongbox. Newman and the group of robbers had been unable to open a larger safe equipped with a timer lock. The robbers rode off, and the train continued its run. As soon as word of the holdup reached the sheriff, a posse was formed. The following day, Thalis Cook and several other Texas Rangers were included. The rangers struck out in pursuit of the outlaws, and thanks to Ranger Cook, an expert tracker, the lawmen made short work of the case. By 27 December 1896, they had four men in custody: Bud Newman, Frank Gobble, Alex Purviance and Rollie Shackleford.

On 30 November 1898, Cook was discharged at Ysleta near El Paso. By the turn of the last century, Cook had passed his fortieth birthday. Cook continued to ranch and worked as a deputy sheriff and cattle inspector, along with participating in a local posse now and then. By 1900, Thalis, his wife Ella, daughter Ina and son John R. were living in Marathon, where he was working as a cattle inspector. By the 1910 census, Thalis, Ella and John R. were living in Bowie County, which is in the extreme northeast corner of the state. It appears as though the Cooks' daughter Ina disappeared from the census records entirely after 1900. Their son John died 12 October 1918, and they had already returned to Marshall from Bowie County by then. Cook's old leg wound continued to give him trouble over the years and ultimately became so painful that had no choice but to have his crippled right leg amputated. As doctors were removing the limb, the battle-scarred old Texas Ranger died on the operating table on 21 July 1918.

After Thalis died, his wife Ella remained in Marshall until her death on 6 April 1925. He is buried beside her, and son John, in the Nesbitt Cemetery just outside Marshall.

Courage is nothing less than the power we have within us to overcome danger and fear. Emerson said, "A hero is no braver than an ordinary man, but he is braver five minutes longer." Perhaps, then, it is audacity that puts the teeth into duty? Unquestionably, Thalis T. Cook is one of the more memorable of those on the list of unsung heroes who made their home a day's ride from here.[30]

THE CATTLE DRIVES

Never approach a bull from the front, a horse from the rear, or a fool from any direction.

—Anonymous

B y some estimates, more than 300,000 head of Texas longhorn cattle were driven north from the Kerr County area to railheads in Kansas during the heyday of the Western Trail. Aggregations as large as 2,500 head or more were assembled on Town Creek just north of Kerrville and driven up the trail to Oklahoma, Kansas and beyond. Considering that roughly 6 million head of cattle and a million horses made their way up the Western Trail, 300,000 might be a conservative estimate. In addition to the traffic on the Western Trail, numerous smaller drives followed the path pioneered by James Patterson, John Chisum, Oliver Loving and Charles Goodnight to New Mexico, Arizona and beyond.

In 1874, Captain John T. Lytle and several cowboys left south Texas with 3,500 head of longhorn cattle and a remuda of saddle horses. Five years later, the route that Lytle cut through the prairie to Fort Robinson, Nebraska, had become the most significant cattle trail in history. Referred to by most as the Western Cattle Trail, but frequently called the Texas Trail, it was far less known than others like the Chisholm Trail, which for the most part was not even in Texas. Other famous routes of the day include the Santa Fe Trail and the Loving-Goodnight Trail.[31] The Western Cattle Trail, which was never prefaced by the term "Great" until recently, had its most distant

Texas longhorn cattle. *Courtesy of Kerr County Historical Commission Archives.*

points of origin in south Texas, with branches beginning at several points in the Rio Grande Valley.[32] It covered a greater distance and carried traffic two years longer than did the more popular Chisholm Trail. The Great Western, which was composed of a dizzying assortment of feeder trails and branches, saw more than 7 million cattle and horses pass through Texas and Oklahoma to the railheads in Kansas and Nebraska, contributing to the development of the cattle industry as far north as Wyoming and Montana.

A typical herd would move ten or twelve miles per day and included the trail boss, a wrangler and a cook. The drive from south Texas to Kansas took about two months, at a cost of $1,000.00 in wages and provisions. At the end of the trail, cattle sold for $1.00 to $1.50 per head. A cowboy made about $10.00 to $25.00 a month, a cook about $30.00 and the trail boss man $100.00.

In Texas, feeder trails from the Rio Grande led to the trailhead near Bandera. The Western passed through Kerrville, Junction, Brady, Coleman, Baird, Albany and Fort Griffin. It is believed that the main streets of Throckmorton, Seymour and Vernon run north–south because of the trail.

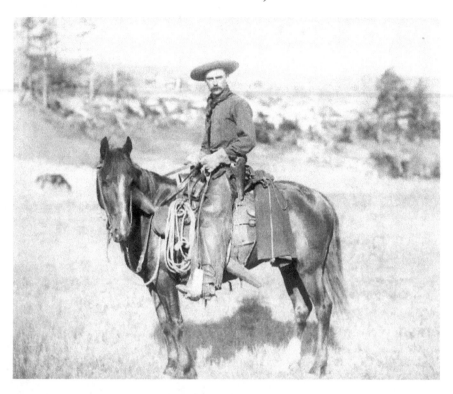

"The Cowboy," an 1888 photo by John C.H. Graybill, who worked between the years of 1887 and 1892 and sent 188 different photographs to the Library of Congress for copyright protection. *Registered at the Library of Congress Prints and Photographs Division as the John C.H. Graybill Collection, LC-DIG-ppmsc-02574.*

Cattle trudged their way across what is now the Lemos Street crossing, or other crossings along the Guadalupe, and passed through the pens along what is now Harper Road. We know that on 5 April 1878 the *Frontiersman* reported that "about 16,000 head of cattle have been driven through this county in the last 10 days…They hail from Medina and Frio Counties, and are on their road to Kansas." Once again on 9 April 1878, the *Texan* reported that "Messers Faltin & Schreiner will start a herd of cattle from here about the 15th to Kansas under the charge of Mr. Jones Glenn."

Captain Schreiner's YO Ranch was actually composed of several ranches, or pastures. The Live Oak Ranch was initially a twenty-thousand-acre spread by itself. By 1900, forty families were living on the Live Oak. Ranchers from all over the Texas Hill Country drove their herds of cattle to the Live Oak to brand them and prepare them for the long trip north to Kansas up the Western Trail. The feeder trail to the Great Western led through the Red's

Charles Armand Schreiner.
*Courtesy of Kerr County Historical
Commission Archives.*

Hole Trap Ranch and the James River Ranch—both were also owned by Schreiner. The Red's Hole Ranch was named after a red dog that drowned in a spring fed by the Devils River. There is an old jailhouse on the ranch that was used to hold prisoners being transported through the area by Texas Rangers and other lawmen.

Robert Real lived in the main house at the Live Oak. He had been a Texas Ranger and had worked for Captain Schreiner in the late 1800s and early 1900s. In gratitude for his service, Schreiner gave Real ten thousand acres just east of the Live Oak. It was originally called the Real Ranch and is today known as the Love Ranch.

As late as 1880, the *Galveston Daily News* reported that the *Mason News* had made claim that "Messers Schreiner & Lytle will, we are informed, send two large droves of cattle up the trail this season." There were various feeder trails linking up to the Western Trail, so all of the cattle heading north did not travel through Kerr County. For instance, the *Galveston Daily News* of 18 April 1876 reported from Gonzales that an estimated twenty thousand head had been driven through that place last week.

An old trail hand named George W. Saunders from San Antonio was interviewed some years later about his experiences on the cattle drives north. George, born at Rancho, Gonzales County, Texas, on 12 February 1854, had been around to witness or hear tales about many of the trail drives up the

Western Trail. On one drive that began late in the trail's eleven-year history he headed out from San Antonio on 5 April 1884. Leaving from Prospect Hill, his outfit headed through Kerrville, Junction City and Seymour, where it crossed the Brazos. From there, the route took them to Dolan's Store on the Red River, where they made their ford. Saunders described the troubles they had on this journey with Indians, stampedes and swollen streams.

The good trail drivers like Ab Blocker, Gus Black, Sim Holstein, Henry Clair, Jones Glenn, Jesse McCoy, Bob Jennings and Bob Lauterday were all record breakers taking cattle up the trail to Kansas. Ab Blocker, born Albert Pickens Blocker in 1856 near Austin, Texas, claimed to have looked down the hairy backs of more cows and drank more water out of a muddy hoof print than any other cowboy extant. During one celebration of the old trail drivers at the Gunter Hotel in San Antonio, Blocker invited John Doak and Bob Lauterday to his room for a drink of bourbon. It would not, of course, have occurred to him to order any ice or even a glass for this toast! As he raised the bottle in his weathered old hand, he exclaimed:

> *We come into this world all naked and bare*
> *We go out of this world we know not where*
> *But if we have been good fellows here*
> *We need not fear what will be there.*

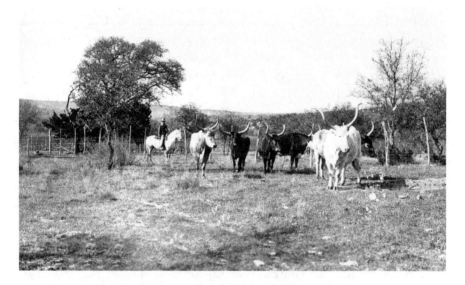

Texas longhorn cattle. *Courtesy of Kerr County Historical Commission Archives.*

Another story recounts the time when, after six successive nights of rain and stampedes, the rain let up on the seventh day, and Blocker took a clean, dry pair of red flannel longhandles out of his saddlebags. He declared that he would give the price of a gallon of good bourbon whiskey for a good night's sleep in those clean, dry clothes as he tied off his horse, Jovero, to the wheel of the chuck wagon and hit the bedroll. At about 11:00 p.m., he was startled awake as he felt the ground under him tremble from the impact of the hooves of frightened cattle taking off in another stampede. Clothed in nothing but his union suit, Blocker swung into the saddle and headed out after the herd. By daylight, he found himself along the Salt Fork of the Brazos, cut off from the main group with a sizeable herd now in his control and wearing nothing but his underwear.

In his older years, Ab Blocker loved to recall stories of certain horses, cows, range characters and dogs. Ab claimed that one particular dog named Hell Bitch could distinguish a branded cow from an unbranded one and never rounded up anything except mavericks.

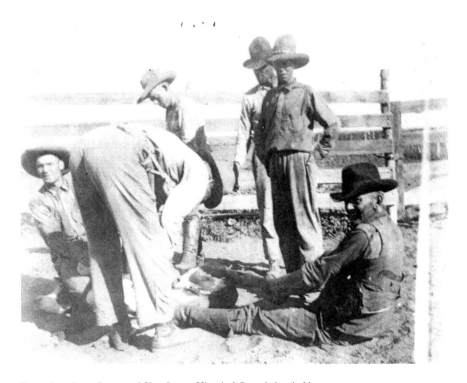

Roundup time. *Courtesy of Kerr County Historical Commission Archives.*

Another amusing story that took place along the Western Trail at the chuck wagon of one of the drives is the encounter the camp cook, Frank Smith, had with some horse thieves. Smith always carried a six-shooter on his hip. While taking the herd through Indian Territory, a few cowboys who were not part of the drive brought a remuda of about fifty horses into camp and approached Smith, asking him for bacon, beans, bread and coffee. When Smith inquired as to the origin of the horses, the cowboys replied, "None of your God-damned business." Smith promptly responded with, "Then it's none of my God-damned business to give you bacon, bread, beans and coffee...I asked you where you got them horses." The cowboy replied, in not-so-proud a tone this time, "I don't know as I want to say," to which Smith replied, "Then I don't know as I want to give you coffee, bread and bacon." Eventually, the cowboy confessed, "Well if you have to know, we stole them from Caddo Indians and we're headed for Texas." At that point, Frank Smith proudly replied, "Come on and eat breakfast...I'll help any man steal from Indians or the Government!"

Henry H. Baker, or "Hen" Baker as he was called, was a stock raiser who hailed from Arkansas and landed a job working for Gus Schreiner in Kerrville. Hen took several herds of cattle up the trail for Captain Schreiner during the heyday of the Western Trail. Many years later, during the 1926 reunion of the old trail drivers, he recalled having supper with the captain. Schreiner had taken the boys on the train to San Antonio as a reward, and they were staying at the Menger Hotel, where Robert E. Lee had once slept. At supper, Schreiner ordered quail on toast. Not wanting to commit a faux pas of etiquette, Hen told the waiter that he would have the same thing and some coffee to go with it. Afterward, he told a friend that "when the waiter brung in that quail on toast it warn't a damn thing but a little old partridge on a slice of scorched lightbread. No meat and not a thing fried."

Some years later, Hen told J. Frank Dobie the story about how a Kerrville grand jury had tried to indict him for killing a man with a pocketknife. The Old Man (meaning Gus Schreiner) had put Hen in charge of parking the horses and wagons at a big barbecue and picnic on the river in order to keep things organized. Soon a man who was pretty well intoxicated came along announcing himself as the Bull of the Bandera Woods and challenged Hen to a fight, calling Hen the King of the Kerrville Cedarbrakes. Hen did not take the bait since he had a job to do for the boss, but later at a downtown bar the man once again called Hen out. Hen, in telling the story all these years later, made a specific point of apologizing for the fact that he was not wearing his six-gun and had no choice but to cut the man's throat with his

pocketknife. Not having his six-gun on was apparently a more egregious offense and worthier of an apology than was the throat-cutting incident. He was acquitted by the grand jury.

Along with pushing Texas beeves up the trail, Hen Baker served as a Texas Ranger in the Frontier Battalion under Captain Neal Coldwell as early as 1872 and 1874. Baker, who passed 22 June 1934, is buried at the Nichols Cemetery near Ingram. Practically every Kerr County old-timer knows the story of Hen Baker. I spoke with one such old hand recently and he recounted as to how he had told the tale of Hen's pocketknife incident many times over the years. "Most folks just don't understand or don't believe that it's true," he said. Back in the day, you simply didn't "call a man out"—especially a man like Hen Baker.

The men of the old cattle drives were hard characters, with all the bark on. They were men like George W. West, who after he and his men lost their homes in Kansas moved all of his stock and remaining possessions, entirely on foot, and began again in Texas.

It was truly a melancholy day for the old cowboys when the era of the trail drives came to an end. Likewise for those of us who draw some measure of the enjoyment from reading about it. The *San Antonio Light* newspaper reported on 30 April 1883 that the cattle drives from Texas that year totaled only 240,000 compared to 350,000 the previous year. By comparison, the *Galveston Daily News* reported on 7 October 1874 that the total for that year was expected to reach more than 500,000, projecting the total commerce at roughly $10,000,000.

Traffic on the Western Trail began to decline in 1885 with the introduction of barbed wire, which is pronounced "bobwire" in Texas. By 1884, cattle drovers had already encountered problems along the Cherokee Strip in Indian Territory. Indians had erected wire fences and armed themselves and were attempting to block passage of cattle north. By 1887, Congress was testing the constitutionality of the fifteen-cents-per-head tax the Chicksaw Indians had been attempting to levy on cattle passing through their land headed north from Texas. Some Texas cowboys, like John Wesley Hardin, refused to pay the tax and simply shot the Chicksaws who attempted to collect the toll. In April 1893, a fight broke out on the Chisholm Trail between cattlemen and Chicksaw police at the Chisholm Trail ford on the Canadian River, forty miles west of Oklahoma City. The cattlemen were driving several hundred head of stock north to Kansas when the Chicksaw police refused to allow them to cross. During the affray, two cattlemen and one unidentified Texan were killed. One Chicksaw policeman was also

killed. The cattle drive was thus forced to take the old Abilene Trail through the Cheyenne Reservation to avoid further conflict.

The record-breaking droughts in Texas during the latter part of the 1800s were also contributing mightily to the demise of the cattle drives north. The *Galveston Daily News* reported on 29 January 1886 that "[a] dispatch announces that there are 15,000 head of cattle dead on the plains a short distance from Fort Elliott in the Texas Panhandle." A similar report claimed that "[t]he cattle in this vicinity are being reduced fearfully by starvation, there being a long draught here there is no grass for their sustenance....there are now about 500 head of cattle dead on the other side of the Nueces... The loss is about 25% of the stock in this entire area."

In 1893, the last large cattle drive up the Western Trail crossed the Red River and headed to Deadwood, South Dakota. Soon the railroads would haul the beeves to market, and the development of refrigeration for railroad cars would make it commonplace for beef from as far away as Kansas and Texas to reach markets in Chicago and the East Coast cities. Sadly, the era of the cowboy was drawing to a close. It is truly remarkable when you reflect on the fact that the age of the great cattle drives from Texas encompassed only a few decades in total. Beginning at about the time of James Patterson's first drives to New Mexico—and including John Chisum, Oliver Loving and Charles Goodnight's epic trail drive from Trickham, Texas, to Bosque Redondo in 1867—the drives all but ended with the last great herd of beeves splashing their way across the muddy Red River in 1893. The era of the cowboy had been born, and had ended, in less than the lifetime of one generation. Hardly the blink of an eye on the timeline of history, but it was perhaps the most celebrated period in the chronicle of the American West.[33]

Assorted Tales Worthy
of Recollection

Tillman A. Corbell

A gentleman named Corbell was a prominent farmer living in Center Point, Kerr County, with his wife, Mary Ann, and a sizeable family consisting of eight children. Corbell and his wife had both been born in Mississippi. William Atterbury, who also resided in Center Point, was from Virginia. His young wife, Sophia, was from Mississippi. On 8 May 1880, the two men were involved in a rather heated dispute over the sale of some cattle. As the disagreement escalated, the forty-year-old Atterbury shot and killed the forty-eight-year-old Corbell. Atterbury then escaped the Kerr County area, never to be seen or heard from again.

W.M.L. Shepherd

W.M.L. Shepherd, who had been born in Virginia in 1846, was living in the home of C.C. Buinlan in Precinct 1, Kerr County. Shepherd might have been a relative or family member of Susan Buinlan, who was also from Virginia, but this has not been adequately documented. Some claimed that Shepherd may not have been the brightest log in the fire, as it is often delicately put. He had traveled to Burnett, where he accidentally shot himself in the leg while he was amusing himself with his own pistol. The bullet traveled downward and severed the femoral artery. It had been hoped that he would recover, but he died of lockjaw on 15 April 1876.

THE SAN ANTONIO AND EL PASO STAGE

On 2 February 1881, the San Antonio newspapers carried a story describing how the San Antonio and El Paso Stage was robbed while passing through Kerr County. No doubt this story was at least in part intended to fuel the citizens' continued concerns about traveling the long and difficult stage route to El Paso while bolstering the Texas and Pacific Railroad's stature as the safer and more modern means of transportation to take. The Texas and Pacific would soon complete its link from San Antonio to El Paso in January 1882.

Between 1851 and 1881, a series of contractors carried the United States mail, as well as passengers, westward from San Antonio to El Paso. Their route traveled through portions of Kerr County. During various periods, the stage line also served Santa Fe, New Mexico and San Diego, California. On 20 September 1851, Henry Skillman obtained a government contract to carry the mail between San Antonio and Santa Fe via El Paso. The first stage carrying the mail headed west on 3 November of that year. In spite of the continual threat of Indian attack, passenger service was added by December. In October 1854, Skillman formed a partnership with George H. Giddings, a San Antonio merchant and freighter. They continued to operate the stage line for the next three years in the face of mounting losses to the Indians. In July 1857, Giddings entered a partnership with James Birch, a well-to-do New Englander. Giddings and Birch operated under government contract to furnish mail service between San Antonio and San Diego on a semimonthly basis, delivering both mail and passengers. The first California mail stage departed San Antonio on 9 July 1857 and reached San Diego on 30 August.

The 1,476-mile, biweekly journey took an average time of twenty-seven days, with the record being twenty-one days. The one-way passenger fare, including meals, was $200. In September 1858, the Butterfield Overland Mail Company began operations between El Paso and California as part of its transcontinental route. This resulted in the post office department making successive reductions in the compensated portions of Giddings's line. His branch service to Santa Fe was terminated in December 1858, and by May 1860 he was receiving payment for service only on the route between San Antonio and Fort Stockton, Texas. Giddings continued to run his coaches all the way to El Paso but operated at a loss. After Texas left the Union in February 1861, Giddings obtained a Confederate government contract to provide service between San Antonio and California, but the Union authorities and hostile Indians soon crippled his operations beyond

El Paso. By August 1862, he had been forced to suspend all service west of Fort Clark, Texas.

Henry Skillman operated a covert courier service between San Antonio and El Paso for the Confederate agents and sympathizers remaining in the area during Union occupation, but federal troops killed him in an ambush near Presidio del Norte in April 1864. Bethel Coopwood revived the San Antonio–El Paso service in April 1866. The line was soon reinvigorated by routing the stages toward the Middle Concho River before turning west to Fort Stockton and by establishing branch routes that served northwestern Texas, Arkansas and the Indian Territory. Service to El Paso continued to be maintained despite Indian raids, banditry and charges of corruption made by political opponents. Despite declining revenues and losses to the Indians, the line kept running until the Texas and Pacific Railroad reached El Paso on 1 January 1882, putting the stage company out of business.

The San Antonio–El Paso stage line rarely turned a profit for its successive operators, but it did have a favorable impact on the state's development. The introduction of a regular means of commercial transportation and the establishment of a chain of fortified relay stations along the road west to El Paso encouraged travel and settlement in the region.

THE GUADALUPE MAIL STAGE LINE

To Kerrville via Leon Springs, Boerne and Center Point from their office at Central Hotel 6:00AM daily (except Sunday) will carry passengers and freight cheaper than the cheapest.
* —W.B. Hawkins, proprietor, 15 August 1886*

THE BONE TRADE

Kansas and other northern states and territories totally quarantined themselves against Texas fever in 1885, closing the trail to Dodge.[34] The trail was the principal thoroughfare over which 2.7 to 6.0 million Texas cattle were claimed to have been moved to market. The fever had plagued the herds of cattle for some years, resulting in the death of literally tens of thousands of animals. The illness, coupled with the severe droughts in Texas during the latter part of the 1800s, brought the industry to its knees. One local family who ranched along "The Breaks" in far west Kerr County recalls stories told

by their grandparents of how so many cattle had died from starvation and the drought that "a man could walk for a hundred miles in this country, stepping from one pile of cow bones to the next, just lying there bleaching in the sun." But like so many disasters in Texas history, industrious ranchers managed to transform tragedy into enterprise. There was a market in the East for buffalo and cattle bones, which were ground up and made into fertilizer. Much like the desperate farmers of Abilene and Taylor County, Kansas, the penniless ranchers of Texas gathered up the bones and shipped them off by wagon to railheads on the Texas and Pacific. The *Galveston Daily News* of 26 November 1879 reported that "several wagons passed through this week going west…a train of wagons loaded with buffalo bones gathered on the plains west of Griffin passed through last Monday." Some shipments of bones traveled by boat from port cities along the Coastal Bend. On 9 November 1887, the *Galveston Daily News* reported that "[t]he Schooner *Luther T. Garretson* is busy being loaded with a cargo of buffalo bones at the Brick wharf." In a single three-month period during the summer of 1881, more than 1,600 rail cars of buffalo bones made their way up the Texas and Pacific track to markets in the North. Initially, the bones brought eight dollars a ton, but as quantities diminished, the price rose as high as twenty-two dollars a ton.

Small wonder that Sam Houston said, "Texas has yet to learn submission to any oppression, come from what source it may."[35]

THE QUIET PASSING OF
AN OLD SOUL

On 12 August 1873, a mail carrier discovered the body of a man lying along the trail about three miles below Zanzenbourg on the way to San Antonio. After learning this from the carrier, George K. Moore of Comfort rode out to investigate and discovered the body of a man, about seventy years old, lying peacefully along the pathway. The dead man's horse was quietly and dutifully standing nearby, with his dog tied to a long lead rope that was tethered to the saddle horn. The saddlebags contained only a few modest articles of clothing and personal items. The man had a pistol and cartridge belt buckled around his waist. He appeared to have died of natural causes, as there was no evidence of foul play.[36]

We come into this world alone and we go out alone. On the one hand, how sad to have one's life end in such a way: alone, on a strange highway, with no one to share your final thoughts and words with and no one to witness your passing. No headstone to mark your final resting place, and no words inscribed thereon to recall your time on earth or perhaps the deeds you performed while here. No mourners weeping, and no preacher reciting "Ashes to ashes and dust to dust." No group of friends and neighbors singing "I'll Fly Away" or "Amazing Grace."

On the other hand, how wonderful to pass from this world in peace and tranquility, in the company of your horse and dog, likely this old soul's best friends and undoubtedly his constant companions—never protesting or complaining and grateful for whatever meager care or attention they received from him. Slipping off silently along a quiet trail on a warm August

day with the smell of cedar in the air and the promise of a cool afternoon rain shower. What better send-off could one hope for?

It pleases me to think about this old-timer. Who was he, and where was he going? What had he done, and what had he seen during his long life? What was he thinking about when he laid down his weary bones for the last time along that stretch of lonely trail just a day's ride from here?

NOTES

INDIAN DEPREDATIONS AND THE BATTLE OF BANDERA PASS

1. The Battle of Mier took place on 25 December 1842 at the town of Mier, Ciudad, Mexico. It has few parallels in our country's history. There was continuous fighting for seventeen hours, with only 260 Texans against 3,000 Mexican soldiers. Texas lost only 11 men, with 22 more wounded. Mexico lost 1,200. Nonetheless, the severely outnumbered Texans were captured and marched two hundred miles to Mexico City, where they were imprisoned.
2. See Moore, *Savage Frontier*, vols. 1–4.
3. Placing it along present-day Old River Road at the foot of Bowlin Drive.
4. Placing them along Elm Pass Road near Verde Creek.
5. Miscellaneous sources for chapter: *Galveston Daily News*, 15 August 1877; Moore, *Savage Frontier*; Cox, *Wearing the Cinco Peso*; Davis, *Texas Rangers*; Wilbarger, *Indian Depredations in Texas*; Sowell, *Texas Indian Fighters*; Hunter, *Pioneer History of Bandera County*; Arnold Cemetery on Hick's Ranch, Medina, Bandera County, Texas; Moore, Elizabeth, died 7/4/1872, mother, killed by Indians in a raid; Moore, Joseph Walker, died 7/4/1872, father, killed by Indians in a raid; Moore, Mrs. William, died 1873, Joseph Moore's mother, killed by Indians in a raid the following year; Alter, *Elmer Kelton and West Texas*; *Galveston Daily News*, 30 January 1877; *Galveston Daily News*, 20 February 1875; believed to have been Samuel Spears from

Lamar County, Texas, who was born in Virginia in 1846, wife Mariah, Paris, Texas Post Office; *Galveston Daily News*, 30 April 1874; *Galveston Daily News*, 15 November 1874; *Galveston Daily News*, 18 November 1874; *Galveston Daily News*, 10 May 1876; *Galveston Daily News*, 10 June 1877; *Galveston Daily News*, 15 August 1877; *Galveston Daily News*, 17 November 1870; and *Galveston Daily News*, 13 May 1873.

The Massacre of the Dowdy Family

6. Miscellaneous sources for chapter: Reverend O.W. Noles, *Kerrville Daily Times*, 7 April 1922; Wilbarger, *Indian Depredations in Texas*; Sowell, *Texas Indian Fighter*; Kerr County Historical Commission; *Galveston Daily News*, 10 October 1878; *Galveston Daily News*, 8 October 1878; *Galveston Daily News*, 27 November 1878.

Frank J. Eastwood

7. Not to be mistaken with a different Frank Eastwood: Joseph Frank Eastwood from Bell County, Texas, who was born in 1844 and who served on the side of the Confederacy.
8. Miscellaneous sources/notes for chapter: Johnson and Miller, *Mason County "Hoo Doo" War*; National Park Service Records of Civil War Soldiers & Sailors; United State Census Records for Texas, 1870; *Galveston Daily News*, 24 July 1873; "Lynch" is short for "lynch law," the punishment of a person for some supposed crime without bothering with the niceties of a legal trial. It is an American expression having its origins in Virginia in the 1780s during the American Revolution. There has been some doubt about which Lynch gave his name to the expression, since there were two men of that name associated with the practice: Captain William Lynch of Pittsylvania County and Colonel Charles Lynch of Bedford County. Both versions have said to be the origin of the term lynch.

William Preston "Bill" Longley

9. Miscellaneous sources for chapter: Bartholomew, *Wild Bill Longley*; Fuller, *Adventures of Bill Longley*; *Galveston Daily News*, 16 September 1877; *Galveston*

Daily News, 7 September 1878; *Galveston Daily News*, 1 August 1877; *Galveston Daily News*, 10 March 1870; Miller, "Boastful Bill Longley."

A VAST ARRAY OF OUTLAWS

10. At least one reliable historian has speculated that the fifth ranger was Davy Tom "D.T." Carson.

11. Captain Gillett's report cites the Eller School by name and places the location as sixteen miles west of Kerrville. Although the exact location of the school is not known, the distance from Kerrville places it at or near Hunt or Mountain Home. James M. Eller served on the Kerr County Grand Jury on 1 August 1873 in connection with vigilante operations. John Mangold and Madera (sp?) Eller were married on 11 July 1871.

12. Ford acquired the lasting nickname "RIP" when he was officially sending out notices of deaths and kindly including at the first of the message, "Rest in Peace." Later, under the exigencies of battle conditions, this message was shortened to "R.I.P."

13. In 1859, the Jackson brothers had a store at the corner of Water and Washington Streets. John E. Ochse also had a sizeable store at the same intersection, where Notre Dame Catholic Church now stands. Ochse provided supplies to Captain John W. Sansom's Texas Ranger Company. Over the years, there was a series of hotels at that corner. An 1898 map of Kerrville shows the Cravey Hotel on the correct corner of Water and Washington. The Cravey Hotel later became the Gerdes Hotel, but during the 1870s it was the Pruitt Hotel.

14. Miscellaneous sources for chapter: *Galveston Daily News*, 29 November 1872; *Galveston Daily News*, 24 July 1873; Malachi M. Weston, 20 November 1872; *Galveston Daily News*, 23 September 1873; Mountainview Cemetery, Kerrville, Texas; *Galveston Daily News*, 28 September 1877; Reverend Noles, *Kerrville Daily Times*, 7 April 1922; United States Census Records, 1870–1880; United States Census Records, 1850, Milam County, Texas; LDS Church Archives: Eli Wickson, born 17 February 1843, Kerrville, Kerr County, Texas, and died 29 July 1924, Beeville, Bee County, Texas, with father Dyrun Wickson and mother Charity Frances Pruett; Washington County Grants located in Brazos County, First Class Headrights, hranted to Dyrun Wickson, 11 December 1841, 1,476 acres; Parsons and Brice, *Texas Ranger*; *Galveston Daily News*, 1 November 1877; *Galveston Daily News*, 18 June 1884; *Galveston Daily News*, 15 January 1885; *Galveston Daily News*,

6 November 1891; Maude Gilliland, "Wilson County Texas Rangers, 1837–1977" (Handbook of Texas Online, 1977); John Warren Hunter, "Literary Effort Concerning Activities of Creed Taylor and Others in the Mexican War" (Austin: Texas State Archives, 1891, Handbook of Texas Online); Harold Schoen, comp., "Monuments Erected by the State of Texas to Commemorate the Centenary of Texas Independence" (Austin: Commission of Control for Texas Centennial Celebrations, 1938, Handbook of Texas Online); Saunders, *Reflections of the Trail*; Hunter, *Trail Drivers of Texas*; Sonnichsen, *Texas Feuds*; O'Neal, *Encyclopedia of Western Gunfighters*; United States Census Records, Texas, 1860, 1870, 1880; *Dodge City Times*, 9 June 1877; Caldwell and DeLord, "Good Men, Bad Men"; Jack Hays Day, *The Sutton-Taylor Feud* (San Antonio, TX: Murray, 1937, Handbook of Texas Online); John Wesley Hardin, *The Life of John Wesley Hardin As Written by Himself* (Seguin, TX: Smith and Moore, 1896; new edition, Norman: University of Oklahoma Press, 1961, Handbook of Texas Online); Marjorie Burnett Hyatt, *Fuel for a Feud* (1987; revised editions, 1988, 1990, Handbook of Texas Online); Napoleon Augustus Jennings, *A Texas Ranger* (New York: Scribner, 1899; revised editions, Austin and Dallas, TX: Graphic Ideas, 1972, Handbook of Texas Online); C.L. Sonnichsen, *I'll Die Before I'll Run: The Story of the Great Feuds of Texas* (New York: Harper, 1951; second edition, New York: Devin-Adair, 1962, Handbook of Texas Online); *Galveston Daily News*, 28 September 1873; *Galveston Daily News*, 16 June 1875; *Texas Escapes* magazine, "History in a Pecan Shell."

THE HARDINS

15. Some historians report that four shots were fired in all rather than three.
16. Miscellaneous sources for chapter: Marohn, *Last Gunfighter*; Metz, *John Wesley Hardin*; *Galveston Daily News*, 18 January 1879; *Galveston Daily News*, 22 January 1879; Herring, *Famous Firearms of the Old West*; Caldwell and DeLord, *Texas Lawmen*.

OTHER HARD CASES

17. Ringo was, on occasion, erroneously referred to as "Ringgold" by the newspapers of the day. There is no evidence that he ever deliberately used that alternate spelling of his surname.

18. Joseph Isaac "Ike" Clanton (born circa 1847, died 1 June 1887) was born in Callaway County, Missouri, and grew up to be one of the pivotal players in the "Gunfight at the O.K. Corral."

19. William "Curly Bill" Brocius (or Brocious) was born about 1845 and died 24 March 1882. Brocius's exact origins are unknown. Before his arrival in Tombstone, he may have been known in Texas as William "Curly Bill" Bresnaham. He is said to have arrived in Arizona Territory about 1878, perhaps from Texas on a cattle drive. More recent research has linked him to a man named Robert Martin. The two men were convicted of a robbery in which a man was killed and were sentenced to five years in prison, but both escaped, presumably to the southwest Arizona Territory. Since both Robert Martin and Curly Bill were leaders of the rustlers in Arizona Territory, they are likely the same Robert Martin and Curly Bill Bresnaham from the Texas crime.

20. John Harris Behan was born 23 October 1844, although some report his birth as being April 1845. He died 7 June 1912. Some report his death as 12 June 1912. In 1866, Behan became undersheriff to John Bourke of Yavapai County, Arizona Territory, where he gained a reputation as a brave and honest lawman. He also served as sheriff in Yavapai County from 1871 to 1872. For twenty-one months of a two-year term spanning the period February 1881 to November 1882, Behan was the sheriff of Cochise County, Arizona Territory. The newly created county, of which Behan was the first sheriff, included the mining boom city of Tombstone, which served as the new county seat. Before being sheriff of Cochise County, Behan served three months as undersheriff of Pima County, Arizona, which at the time included Tombstone. He succeeded Wyatt Earp in that position. Behan is known for being county sheriff at the time of the "Gunfight at the O.K. Corral" and was later a factor in Wyatt Earp's Vendetta Ride. In 1888, Behan became superintendent of the Territorial State Prison at Yuma. Later, he was a U.S. agent at El Paso, where he attempted to control smuggling in the area. Behan was also employed as a government special agent in China during the Boxer Rebellion. Behan is buried at the Holy Hope Cemetery and Mausoleum at Pima County.

21. Wyatt himself claimed this in at least three places, including the Forrestine Hooker manuscript.

22. The grave is located on private land, and permission is required from the owners to view the grave site.

23. Miscellaneous sources for chapter: Burrows, *John Ringo*; Texas State Archives, call no. 401-50, Texas Ranger Service Records; Caldwell, *Dead Right*.

William Scott Cooley

24. Sometimes spelled "Worhle."

John D. Nelson

25. Miscellaneous sources for chapter: *Galveston Daily News*, 16 November 1882; *San Antonio Evening Light*, 14 November 1882; *San Antonio Daily Express*, 14 November 1882; *Galveston Daily News*, 14 July 1886; Texas State Archives, Texas Ranger Records, call no. 401-165; National Park Service Records of Civil War Soldiers, Jones's Company Texas Light Artillery; Kerr County Historical Commission, 1865–1900; Texas Peace Officer Memorial Foundation; United State Census Records, Texas, 1850, 1860, 1870 and 1880.

Davy Thomas Carson

26. The term "Blue Norther" refers to a swift-moving cold frontal passage in the southern Great Plains, marked by a dark, blue-black sky with strong wintry winds.
27. Present-day Earl Garret Street.
28. Miscellaneous sources/notes for chapter: Texas State Archives & Library, Austin, Texas, call no. 401-146. Carson's records are filed under the name "D.T. Carson" and also under the name "Tom Carson." A comparison of the records reveals that they are the same; "George Davis" is believed to have been an alias used by Caleb Hall, who also went by the names "John Collins" and "George Graham"; unmarked graves in Kimble County: Big Paint Creek Cemetery, Telegraph, Kimble County, Texas—this all but forgotten cemetery is located on the Big Paint Creek ranch near Highway 377, about four miles south of Telegraph; following are several unknown graves: Copperas Cemetery, Kimble County, Texas, on FM 1674 near its intersection with IH-10, a deed for this cemetery was executed by D.P. Cowsert to E.S. Alley, county judge, on 30 May 1890, donating one acre of land out of E.S. Haines Survey #55; one grave suspected to be that of Texas Ranger Davy Thomas "Tom" Carson; Gentry Creek Cemetery, Kimble County, Texas, on Highway 377, about five miles northeast of Junction, one of the earliest cemeteries in Kimble County. One grave

here is that of Allen Gentry, killed by Indians in 1867 at Leon's Point in Mason County; Red Creek Cemetery, Kimble County, Texas, on KC 340 south of London, the land for Red Creek Cemetery was donated to the community by Frank Latta on 23 May 1896 to be used "for general burial purposes"; Rembold Ranch/Joy Settlement Cemetery, Kimble County, Texas, several unknown graves; Wooten Cemetery, Kimble County, Texas. Typical of burial sites chosen by early Texas Hill Country pioneers, Wooten Cemetery was established by April 1880 when one-year-old Cornelius Clay Jackson was buried. His headstone is the earliest gravemarker in the cemetery; other unknown graves include the following: an unknown grave is located on the Edd Hunger ranch. Boyce Hunger told us about the grave but has no other information; an unknown grave, possibly that of a child, is located on the side of the hill and alongside the road between Walnut Canyon ranch headquarters and the Felix Murr ranch. Nothing remains except rocks covering the grave and a tumbled-down picket fence at the foot of a juniper tree; two visible graves are located on the West Bear Creek ranch belonging to Ann Burton Patton. It is thought these unknown persons may have been traveling through the countryside on the old road to Fort McKavett; an unknown grave is located (no present evidence) near the foot of Twin Peaks off Elm Slough Road. Marlow Taylor told us about seeing the grave site in the 1930s, and Marvel Skaggs Moss reported that her father, Marvin Skaggs, thought that a small daughter of a family traveling through the country had died and was buried there many years ago. A grave on the old W.W. Wood place on Bear Creek was visible for many years, according to old-timers; L.B. Caruthers is sometimes misleadingly referred to as "L. Carruthers." There was another Texas Ranger named L. Carruthers, but he was not the same person as the one who participated in the capture of Evans; Cox, *Texas Ranger Tales*; Thrapp, *Encyclopedia of Frontier Biography*, vol. 1; Miller and Snell, *Gunfighters of the Kansas Cowtowns*; McCright and Powell, *Jessie Evans*; Wilkins, *Texas Rangers*; Caldwell, *Dead Right*; Sergeant Kyle L. Dean, Texas Rangers Company F, source of possible location of Carson's grave, Kyle L. Dean to Clifford R. Caldwell; Andrew Jackson "A.J." Royal was born in Lee County, Alabama, on 25 November 1855. Royal had married Naomi Obedience Christmas on 19 January 1879 at Junction City, Mason County. Naomi had been born at Coryell County, Texas, on 13 November 1863, and she lived until 1 September 1950, dying at San Angelo, Tom Green County, Texas. It was the first such establishment in Junction City. The previous owner, William Homer Franks, had been

born in New York on 7 September 1850 and by 1880 was operating a saloon in nearby Maverick County. After his first wife passed, he came to the Junction area and married Sarah Josephine Wilson on 14 February 1882. A.J. Royal bought 265 head of cattle and an 1,800-acre ranch with irrigated land seven miles west of town. He also set up a saloon business and bought the former post trader's building in town. Royal ran for commissioner in 1890 and won, later winning a subsequent election to the post of sheriff of Pecos County on 8 November 1892.

THALIS TUCKER COOK

29. Folliard is often misspelled as "O'Folliard." Although Tom's surname may actually have been spelled "Filliard," "Foliard" or "Fuliard," it was not "O'Folliard." That is an error that has been perpetuated for decades until corrected by the author.

30. Miscellaneous sources for chapter: O'Neal, *Encyclopedia of Western Gunfighters*; Miles, *Tales of the Big Bend*; E.C. Eckhardt, "The Murder Maverick," *Texas Escapes* online, 29 May 2009; Mike Cox, "The Bud Newman Gang," *Texas Escapes* online, 26 May 2009; Spellman, *Captain John H. Rogers*.

THE CATTLE DRIVES

31. The Loving-Goodnight Trail is also John Chisum's Western Trail.

32. The addition of the prefix "Great" to the Western Trail has been attributed to the chamber of commerce of Seymour, Texas. Although it is unclear if the town deserves this distinction, it is true that its main street was at one time the path of the Western Trail.

33. Miscellaneous sources for chapter: *Galveston Daily News*, 16 April 1880; Myra Busby, managing director, Seymour, Texas Chamber of Commerce; *Galveston Daily News*, 5 April 1878; *Galveston Daily News*, 9 April 1878; Hunter, *Trail Drivers of Texas*; Dobie, *Cow People*; *San Antonio Light*, 30 April 1883; *Galveston Daily News*, 7 October 1874; *Galveston Daily News*, 18 April 1876; *Galveston Daily News*, 19 April 1889; *Galveston Daily News*, 29 January 1886; *Galveston Daily News*, 20 February 1872.

Assorted Tales Worthy of Recollection

34. The disease was caused by a microscopic protozoan that inhabited, and destroyed, the red blood cells called Pyrosoma Bigeminum.
35. Miscellaneous sources for chapter: *Galveston Daily News*, 11 May 1880; *Galveston Daily News*, 15 April 1876; *San Antonio Light*, 4 July 1883; *Galveston Daily News*, 1 January 1882; San Antonio El Paso Stage (Handbook of Texas Online); *San Antonio Daily News*, 15 August 1886; *Galveston Daily News*, 26 November 1879; *Galveston Daily News*, 9 November 1887.

The Quiet Passing of an Old Soul

36. *Galveston Daily News*, 13 August 1873. Also, Zanzenbourg was the earlier name for the present-day town Center Point, Kerr County, Texas.

BIBLIOGRAPHY

Adams, Clarence S., and Tom E. Brown. *Three Ranches West.* New York: Carlton Press, 1972.

Alter, Judy. *Elmer Kelton and West Texas.* Denton: University of North Texas Press, 1989.

Atherton, Lewis. *The Cattle Kings.* Bloomington: Indiana University Press, 1967.

Bartholomew, Ed Ellsworth. *Wild Bill Longley: A Texas Hard-Case.* Houston, TX: Frontier Press, 1953.

Bonney, Cecil. *Looking Over My Shoulder: Seventy Five Years in the Pecos Valley.* Roswell, NM: Hall-Poorbaugh Press, Inc, 1971.

Burrows, Jack. *John Ringo: The Gunfighter Who Never Was.* Tuscon: University of Arizona, 1987.

Caldwell, Clifford R. *Dead Right: The Lincoln County War.* Mountain Home, TX: privately published, 2008.

Caldwell, Clifford R., and Ronald G. DeLord. "Good Men, Bad Men: Texas Lawmen, 1835–1899." Unpublished manuscript, 2010.

———. *Texas Lawmen, 1835–1899: The Good and the Bad.* Charleston, SC: The History Press, 2010.

Clarke, Mary W. "History of Clarksville." *Paris News,* 7 December 1943.

———. *John Simpson Chisum.* Austin, Texas, Cooke County Deed Book 4, 1984, 105.

Cox, Mike. *Texas Ranger Tales.* Dallas: Republic of Texas Press, 1997.

———. *Wearing the Cinco Peso, 1821–1900.* New York: Tom Doherty Associates, LLC, 2008.

Davis, John L. *The Texas Rangers: Images and Incidents.* San Antonio: University of Texas Institute of Texan Cultures, 2000.

Dobie, J. Frank. *Cow People.* Boston, MA: Little, Brown & Company, 1964.

Fuller, Henry Clay. *The Adventures of Bill Longley.* Nacogdoches, TX: Baker Printing, 1976.

Herring, Hal. *Famous Firearms of the Old West.* Helena, MT: TwoDot, Globe Pequot Press, 2008.

Hunter, John Marvin. *Pioneer History of Bandera County.* Bandera, TX: Hunters Printing House, 1922.

———. *The Trail Drivers of Texas.* Austin: University of Texas, 2006.

Johnson, David, and Rick Miller. *The Mason County "Hoo Doo" War, 1874–1902.* Denton: University of North Texas Press, 2006.

Klasner, Lily. *My Girlhood Among Outlaws.* Tucson: University of Arizona, 1972.

Marohn, Richard C. *The Last Gunfighter: John Wesley Hardin.* College Station, TX: Creative Publishing, 1995.

McCright, Grady E., and James H. Powell. *Jessie Evans: Lincoln County Badman.* College Station, TX: Creative Publishing Co., 1983.

Metz, Leon C. *John Wesley Hardin: Dark Angel of Texas.* Norman: University of Oklahoma Press, 1998.

Miles, Elton. *Tales of the Big Bend.* Library of Congress. College Station: Texas A&M University, 1976.

Miller, Nyle H., and Joseph W. Snell. *Gunfighters of the Kansas Cowtowns, 1867–1886.* Lincoln: University of Nebraska Press, 1963.

Miller, Rick. "Boastful Bill Longley: Cold-blooded Texas Killer." *Wild West,* February 2002.

Moore, Stephen L. *Savage Frontier.* Vol. 4. *1842–1845.* Denton: University of North Texas Press, 2010.

Nolan, Frederick. *The Life and Death of John Henry Tunstall.* Albuquerque: University of New Mexico, 1965.

O'Neal, Bill. *Encyclopedia of Western Gunfighters.* Norman: University of Oklahoma, 1979.

Parsons, Chuck, and Donaly Brice. *Texas Ranger N.O. Reynolds: The Intrepid.* Honolulu, HI: Talei Publishers, 2005.

Redfield, George B. *Comanche Indians on Chisum Cattle Trail.* Checked by Lucius Dills, Roswell historian, paraphrased by C.W. Barnum, in the words of Sallie Chisum Roberts. American Life Histories: Manuscripts from the Federal Writers' Project, 1936–40, handwritten manuscript.

Sonnichsen, C.L. *Texas Feuds.* Albuquerque: University of New Mexico, 1971.

Sowell, A.J. *Texas Indian Fighters.* Abilene, TX: State House Press, McMurry University, 2005.

Spellman, Paul N. *Captain John H. Rogers, Texas Ranger.* Denton: University of North Texas Press, 1971.

Texas Escapes magazine. "History in a Pecan Shell." 4 July 2007.

Thrapp, Dan L. *Encyclopedia of Frontier Biography.* Vol. 1. Spokane, WA: Arthur H. Clarke Co., 1990.

Wilbarger, J.W. *Indian Depredations in Texas.* Austin, TX: Hutchings Printing House, 1889.

Wilkins, Frederick. *Texas Rangers: Life on a Scout.* Waco: Texas Ranger Hall of Fame and Museum, 2003.

INDEX

ABOUT THE AUTHOR

C liff Caldwell has continually cultivated his interest in western history since boyhood. After a stint in the United States Marine Corps during the Vietnam War, as well as a successful thirty-five-year career working for several Fortune 500 corporations, Cliff is now retired and free to pursue his interests as a historian and writer on a full-time basis. Cliff holds a Bachelor of Science degree in business and is the author of several

Photo by Ellen D. Caldwell.

books and published works, including *Dead Right: The Lincoln County War, Guns of the Lincoln County War, A Day's Ride from Here, John Simpson Chisum: The Cattle King of the Pecos Revisited* and his most recent work, *Texas Lawmen 1835–1899.*

Cliff is recognized as an accomplished historian and researcher on the American West. He is a member of Western Writers of America, Inc.; the Wild West History Association; the Texas State Historical Association; and the Buffalo Bill Historical Center. When not deeply involved in writing, Cliff volunteers some of his time doing research for the Peace Officers Memorial Foundation of Texas.

Cliff and his wife live in the Hill Country of Texas, near Mountain Home.

Visit us at
www.historypress.net